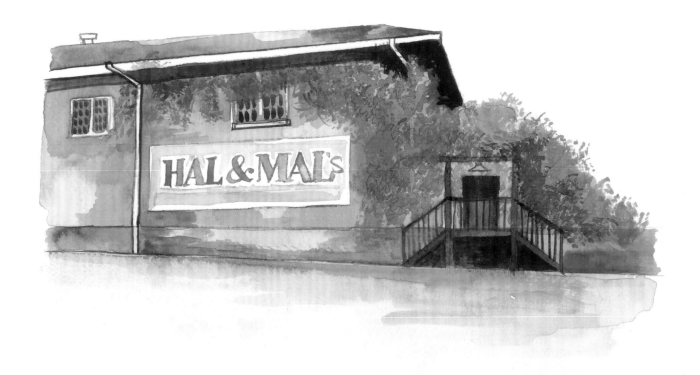

THE ARTFUL EVOLUTION OF
HAL & MAL'S

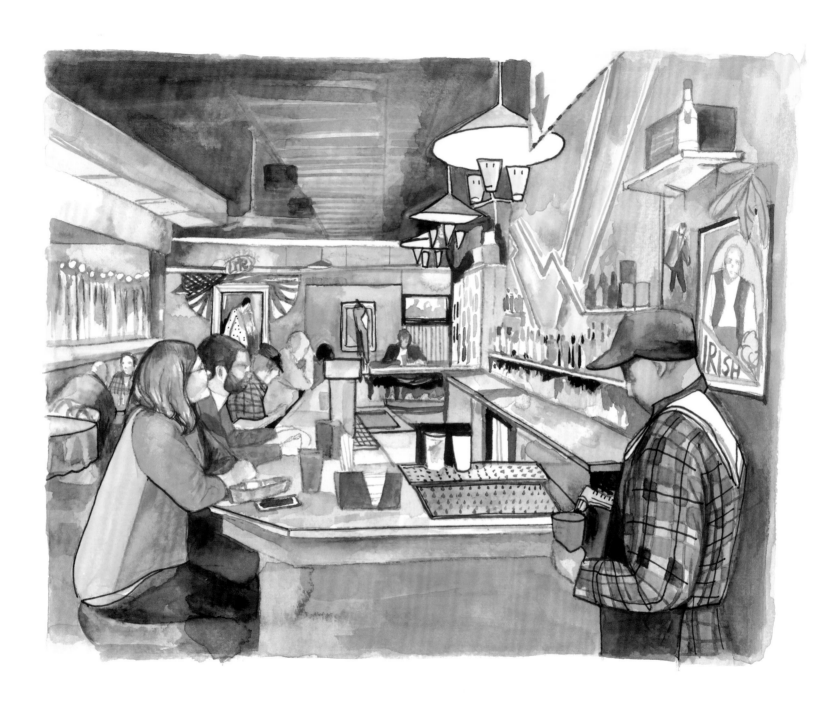

THE ARTFUL EVOLUTION OF
HAL & MAL'S

MALCOLM WHITE * ILLUSTRATED BY GINGER WILLIAMS COOK * FOREWORD BY ROBERT ST. JOHN

UNIVERSITY PRESS OF MISSISSIPPI / JACKSON

www.upress.state.ms.us

The University Press of Mississippi is a member
of the Association of American University Presses.

Designed by Todd Lape

Illustration page iv: Day shift with lunch customers;
Maggie Stevenson, Graham Carner, Darryl Dampier

First printing 2018
∞

Library of Congress Cataloging-in-Publication Data

Names: White, Malcolm, 1951– author.
Title: The artful evolution of Hal & Mal's / Malcolm White ;
illustrated by Ginger Williams Cook.
Description: Jackson : University Press of Mississippi, [2018] |
Includes index. |
Identifiers: LCCN 2017032187 (print) | LCCN 2017033174 (ebook)
| ISBN 9781496816894 (epub single) | ISBN 9781496816900
(epub institutional) | ISBN 9781496816917 (pdf single) |
ISBN 9781496816924 (pdf institutional) | ISBN 9781496812032
(hardcover : alk. paper)
Subjects: LCSH: Hal & Mal's (Restaurant)—History. |
Nightclubs—Mississippi—Jackson. | White, Malcolm, 1951– |
White, Harold Taylor, Jr., 1949–2013. | Restaurateurs—United
States—Biography. | Socialites—Mississippi—Biography.
Classification: LCC TX945.5.H34 (ebook) | LCC TX945.5.H34
W55 2018 (print) | DDC 647.95762/51—dc23
LC record available at https://lccn.loc.gov/2017032187

British Library Cataloging-in-Publication Data available

This book is dedicated to the love and memory of my brother, Harold "Hal" Taylor White Jr., and to my mother-in-law, "Mama" Zita Radakovitz Pigott, and to the countless cups of morning coffee and lifetimes of stories they shared.

CONTENTS

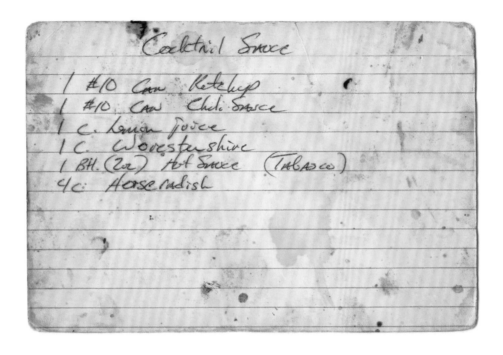

Hal's recipe cards for cocktail sauce and crawfish chili

FOREWORD

Independent restaurants anchor a community. They tell the story of a town and its people much better than a slick chamber of commerce brochure.

When I am traveling, I skip meals at the hotel and ask the front desk clerk, "Where's the best place to eat? Not a chain, nothing fancy, I'm looking for the place where the old men sit at the same table and annoy the same waitress while talking politics and sports."

I am always in search of a restaurant, diner, or cafe where "local color" lives. It is within those walls that I'll learn about that town and its people.

In Jackson, Mississippi, there are several old-line community-defining restaurants and cafes. The Mayflower, the Elite, and—even though it exists in a newer incarnation—Primos are all heritage restaurants. Those places tell the story of Jackson. They were the first of their kind, and, in an industry that is not deferential to tenure, they continue to thrive today.

When looking at the history of restaurants, it's the old-line places that establish the initial culinary culture of a community. The second-generation restaurants are the ones that break new ground and introduce us to new styles, trends, and concepts.

No restaurant represents the second generation of Jackson dining better than Hal & Mal's.

I have long stated that Hal & Mal's doesn't get the credit it deserves for changing the culture of downtown Jackson, and therefore, Mississippi. In the mid-1980s when the capital city's white flight was making a swift migration north, brothers Hal and Malcolm White boldly planted their flag in a B-location on South Commerce Street inside an old warehouse next to the railroad tracks, where they began offering first-class gumbo and world-class music.

Oftentimes we get distracted by the shiny new things and forget to pay homage to the classics. Hal & Mal's is a classic in the most classical sense. The White brothers—late, great soup

Hal's famous coleslaw recipe

master, Hal, and music promoter wunderkind, Malcolm—opened the iconic establishment in 1985 after a decade or more of working in other people's operations.

Hal & Mal's was groundbreaking when it opened, and it continued to break new ground for the next two decades. When industry trends and cultural shifts threw them a curve ball, the brothers corrected their course, steadied their stance, and swung for the fence every time.

To survive through the ages, a restaurant must always move forward.

In the early days, Hal & Mal's was the premiere spot for live music in Mississippi. With Arden Barnett riding shotgun, Malcolm White broke through the old established barriers of entertainment booking and brought cutting-edge live music to the Hal & Mal's big room. It's one thing to introduce new music to an audience. It's a more important thing to shine a light on heritage acts that were forerunners of modern genres. Artists such as Willie Dixon, B. B. King, Ike Turner, Albert King—the reasons our current music exists—performed on the Hal & Mal's stage, along with hundreds of others.

Malcolm White has accomplished many things over the course of a long, successful career. Possibly the most overlooked aspect of White's resume is that he, and not a minute too late, brought attention and appreciation to jazz and blues musicians, who were there at the birth of twentieth-century music, minutes before they made their exit. In the mid-1990s the casinos opened and—armed with large entertainment budgets aided by slot machine and table-gaming profits—began competing in the live music segment.

The White brothers adjusted course and, in what might have been their boldest move, made a daring foray into the brewpub industry fifteen years before anyone cared about beer beyond the long-established macro breweries. Craft beer is ensconced in the state's vernacular today. But I defy anyone to name a restaurant or bar that was more influential to the craft beer business (early on) than Hal & Mal's— Mississippi's first independent brewpub.

Had the Whites opened their brewpub in 2014 instead of 1999, we'd be talking about a different downtown landscape.

The first beer the White brothers brewed was Willie's Diamond Ale, a spring beer named for the famous Mississippi author Willie Morris who passed away while they were building the brewery. Ultimately the Whites were too early for the general public and too late for Willie, though Morris would have loved both the beer and the tribute.

Fish camp gumbo recipe

As the Bold New City's mass exodus continued—later in all directions—the White brothers held firm to their downtown roots. They kept booking live music in the face of well-funded competition, they continued to welcome every charity that knocked on their door needing an event space, and they fired up the stoves every morning and made killer gumbo and the best hot roast beef sandwich east of the Mississippi River.

The restaurant community lost Brother Hal in the spring of 2013. But the next generation of Whites stepped up to the plate. In my mind, that was a defining moment in the history of Hal & Mal's. Everyone wondered if the restaurant could carry on without Hal. Malcolm had moved on to a career in state government with the Mississippi Arts Commission, where he was able to use his considerable skill and experience to promote the arts and music to a broader base beyond a single restaurant/bar. Without hesitation, the next generation of Whites took the reins of the restaurant and bar, cementing Hal & Mal's into a true Mississippi institution.

The sign of a lasting culinary legacy is when the next generation takes charge without missing a beat.

It is important that we support these institutions while they still operate. Too many great restaurants have gone on to that great used-equipment warehouse in the sky because the new, shiny things distracted us. When they have departed, we lament the loss, though way too late.

We need to support our classic restaurants and bars, not only because they have excellent food and entertainment, but because they are good for Mississippi. They tell our story in the best way possible.

If there were a Jackson Restaurant Hall of Fame (and there should be), the names of the Greek restaurant greats Apostle, Crechale, Dennery, Kountouris, Primos, and Zouboukos—first-ballot candidates, all—should be listed with the same reverence as the two boys of Scotch Irish descent from south Mississippi, Hal and Malcolm White, who have given us "local color" for over three decades.

—Robert St. John

ACKNOWLEDGMENTS

I am greatly appreciative of Ginger Williams Cook and her willingness to throw in with me on this project. I admire her work, and I knew from the first sketches I saw in her notebook that she had the eye for the stories I wanted to share about Hal & Mal's. I also thank Leila Salisbury, former director of the University Press of Mississippi, for supporting and seeing merit in this project and current director Craig Gill for seeing it through to fruition. I am grateful to Emily Bandy, Valerie Jones, and Todd Lape at the Press and to copyeditor Ellen Goldlust for their patience, guidance, and good orderly direction. I thank Robert St. John and Sallye Killebrew for contributing and listening and sharing. And finally, I am grateful to my family for allowing me to share our story and to Kara Norris, my partner and steadfast love, for being there and keeping me grounded.

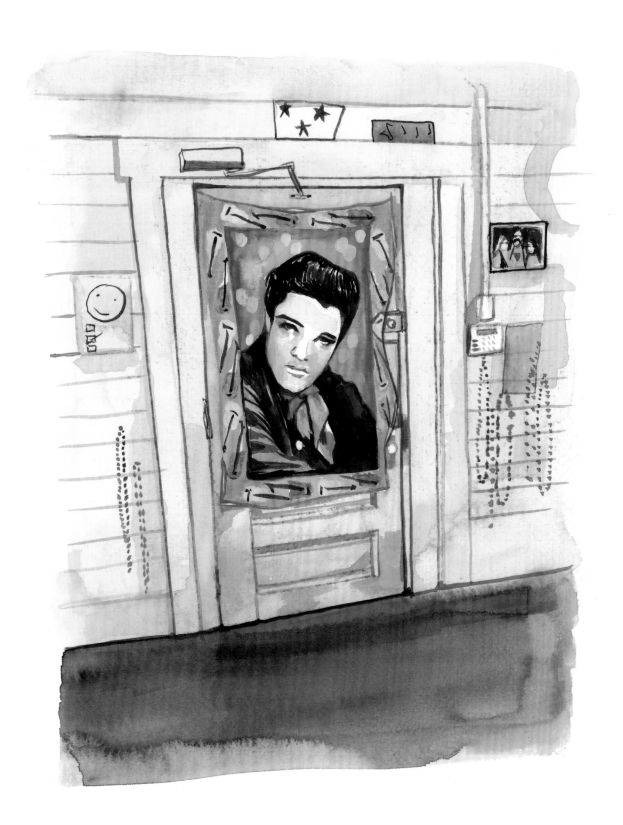

Velvet Elvis #2 in the office, or the Mr. Dink Drennan Room. Folk art by Raphael Semmes.

INTRODUCTION

This eclectic art project, cleverly disguised as a book about a bar and restaurant, is a collaboration between artist Ginger Williams Cook's illustrations and my recollections of the people, the place, and the history of Hal & Mal's, an iconic eating, drinking, and gathering place—some say an institution—in downtown Jackson, Mississippi. Although 59 percent of hospitality businesses fail within three years of their founding, Hal & Mal's has remained in operation for more than three decades—and counting. Longevity notwithstanding, the major tenets of our business philosophy have always been (1) embrace art, culture, and creativity as a strategy, not an afterthought; and (2) the more we give, the more successful we are. Thus, as we evolved, we became successful, and as we became successful, we became more artful and more important to the community we chose to serve. I have borrowed the concept for the book from two of my best friends and collaborators, Robert St. John and Wyatt Waters. I can only dream that this project will have as much success as the volumes and art those two create.

Hal & Mal's was originally operated by my brother Hal and me as well as my wife, Vivian Pigott Neill, though she and I later divorced. Later in the journey, Ann White worked alongside Hal, and then we were joined by Hal and Ann's daughter, Brandi; her then-husband, P.J.; my daughter with Vivian, Zita Mallory; Zita's husband, Webb; and Hal and Ann's son, Taylor. Until her passing at age ninety-six, Zita Radakovitz Pigott worked the front counter from Day 1. Beyond family, we have been blessed with hundreds of outstanding managers and employees. Some have been here from the beginning and some for just a week, but all represent the connections among our philosophy, the product we provide, and the often-illusory concept of service. I have wracked my brain trying to create an all-encompassing list of these good folks, but no matter how long the list becomes, I always think of someone I have left out. So to avoid omitting someone near and dear to these three decades of effort, I will simply say thanks to all of you. You know who you are. But one such person must be named: Delta State University professor Charles Abraham

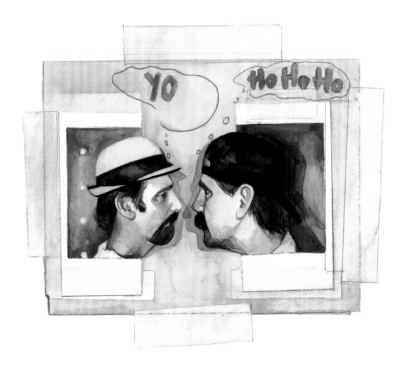

Employee notice of Natchez Christmas trip. Yo (Mal), Ho Ho Ho (Hal).

devoted over twenty years to tending bar, booking bands, playing drums, and managing both the restaurant/bars AND the parade. Thanks, Charly!

My dear old friend, newsman Bert Case, used to joke with me about the first time I told him I was going to open Hal & Mal's. I served and socialized with Bert for many, many years at George Street Grocery, the epicenter of downtown Jackson politics and media in the 1970s and 1980s. I ran into Bert sometime after I completed my tenure as manager of this venerable watering hole, and he asked about my future plans. I explained that my brother and I were going to open a bar, restaurant, and live music venue in the old GM&O Freight Depot on Commerce Street, just down the block from WLBT, where Bert held court nightly during the five o'clock and ten o'clock evening newscasts alongside Woodie Assaf, Marsha Thompson, Dennis Carl Smith, and my best friend from Booneville, the irrepressible Michael Rubenstein. Case listened politely and then shook his head with a smirk and slowly said, "Malcolm . . . you're going to lose your ass!" Many years later, as we relived that conversation and his miscalculation of my risky little enterprise, he would add, "Malcolm, when you told me about Hal & Mal's, I thought you guys were nuts, and that y'all needed to be institutionalized. Now you, your brother, and your business have become an institution! Man, was I wrong about that." Sadly, we lost the voice and our beloved Berrrrrt Case in 2016, but his influence and legacy live on in local lore.

Our dream of Hal & Mal's was rooted in an active culinary childhood on the Mississippi Gulf Coast, reinforced by years of living and working in New Orleans, and ultimately launched in Jackson in 1985. This gathering place has always been owned and operated by family—now the second and third generations. The multifunctional, southern-soul-soaked rooms are adorned with memorabilia and chock-full of local character; each one also features a stage for live music. The kitchen serves a steady offering of hearty regional staples with a nod toward the Gulf of Mexico. My buddy Bill Ellison always says, "Hal & Mal's is the most-talked-about upscale honky-tonk in all of Mississippi." It is a place where art is made, music plays, and folks gather to share community and celebrate the very best of Mississippi's creative spirit.

Until as recently as the 1960s, Mississippians traditionally entertained at home with friends or family rather than in restaurants, cafés, or other public eating facilities. Perhaps partly because of isolation, poverty, and the resulting lack of sophistication and/or education, Jackson had little dining-out culture beyond the historically significant Greek-owned eateries sprinkled around downtown, particularly along the major thoroughfares of Capitol Street and Highway 80. The Rotisserie,

the Mayflower Café, Dennery's, the People's Cafe, Fisherman's Wharf, Bill's Burger House, Primos, Crechale's, Paul's, and the Elite kept us sustained and entertained until other places of public dining began to arrive in the late 1970s. Hal & Mal's may not belong in the same rarified league as these formidable places, but when we opened, their success, their history, and their sense of place strongly influenced our ambitious plans.

Paul's Restaurant at 1955 Highway 80 West was the companion eatery to the Stonewall Jackson Motor Court in south Jackson. Owner/manager Paul Apostle served the standard fare of the 1950s southern palate with a healthy dash of Greek American influence. The establishment not only served visitors but was a must for Sunday after-church lunch for many generations of white Jackson society. LeFleur's played a similar role alongside the Jacksonian Inn in north Jackson. Paul Apostle's son, Nick, became Mississippi's most celebrated and successful chef, owning and operating Nick's on Lakeland Drive for many years. By the mid-1980s, the Apostle family moved on, the character of Highway 80 began to change, and much of Greater Jackson began to migrate north and northeast. Hal went to work as the night cook for Paul's, run by Tim and Debbie Glenn, members of the family also known for operating Rooster's, Basil's, and the Feathered Cow. During the day, my brother and I worked to create Hal & Mal's. And while Hal and I were creating this place, Ginger was growing up on the other side of the counter as one of our patrons.

The first concert at Hal & Mal's featured blues icon Albert King, but our history really goes back much further—to 1927, when the building that now serves as our home was constructed. These walls hold great stories. My brother regularly spoke of encounters with ghosts, and several people have told me that Elvis himself picked up and delivered goods here back in his truck-driving days.

The millions who have come and gone through our doorway have included both the famous and the not-so-famous. John Grisham was a relatively unknown state legislator when we hosted his first book signing in 1988. To thank us, he wrote in his 2013 novel, *Sycamore Row*, "Wade Lanier's favorite lunch spot was Hal & Mal's, an old Jackson haunt a few blocks from the state capitol and a ten-minute walk from his office on State Street. He took his favorite table, ordered a glass of tea, and waited impatiently for five minutes until Ian Dafoe walked through the door and joined him."

This book project offers another way to join us. It provides a glimpse into our family history, our live music performances, our good, solid grub, and our very own southern-style café society viewed through a graphic novel lens envisioned by Ginger. This book is not meant to be a vertical history or a chronological history of our family; rather, it is a collection of words and art that attempts to capture our sense of home and community; the manner in which we gather for food, drink, and fellowship; and most important, the people with whom we gather. In some cases, my written vignette is a response to Ginger's art; in others, her art pieces illustrate one of my short stories; but we are always dancing and playing off one another, just like we do at Hal & Mal's.

Sketch of front bar with Green
Derby Restaurant light fixture
and neon patio sign

ARTIST'S STATEMENT

Being a Jackson native, Hal & Mal's has been a part of my life as long as I can remember, beginning with going to the St. Paddy's Parade as a child. I lied to my parents to go see a rock band play there when I was in the eighth grade and later celebrated the engagement to my husband in the same space. It also became a place where friends of mine gathered when we tragically lost close friends. I am deeply connected to the legacy of Hal & Mal's, and it is an honor to illustrate the history of such a special place.

The illustrations were done using watercolor and gouache on textured paper. Keying the paper with rich sepia tones and splashes of color helped capture the mood that's distinctly Hal & Mal's. Before the project began, I spent a week sketching during the lunch crowds and taking photos of the details as Malcolm shared family history through the nooks and crannies of the restaurant. The paintings were later created in my studio using photographs as a reference point. Creating a sense of place and connection through drawings and watercolor on paper was made possible because of the restaurant and family's storied past and present.

—Ginger Williams Cook

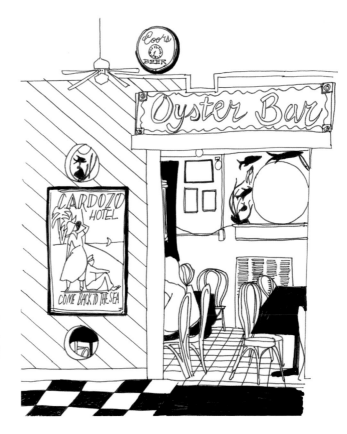

Oyster Bar sketch with Ed Millet art and Carole Pigott signage

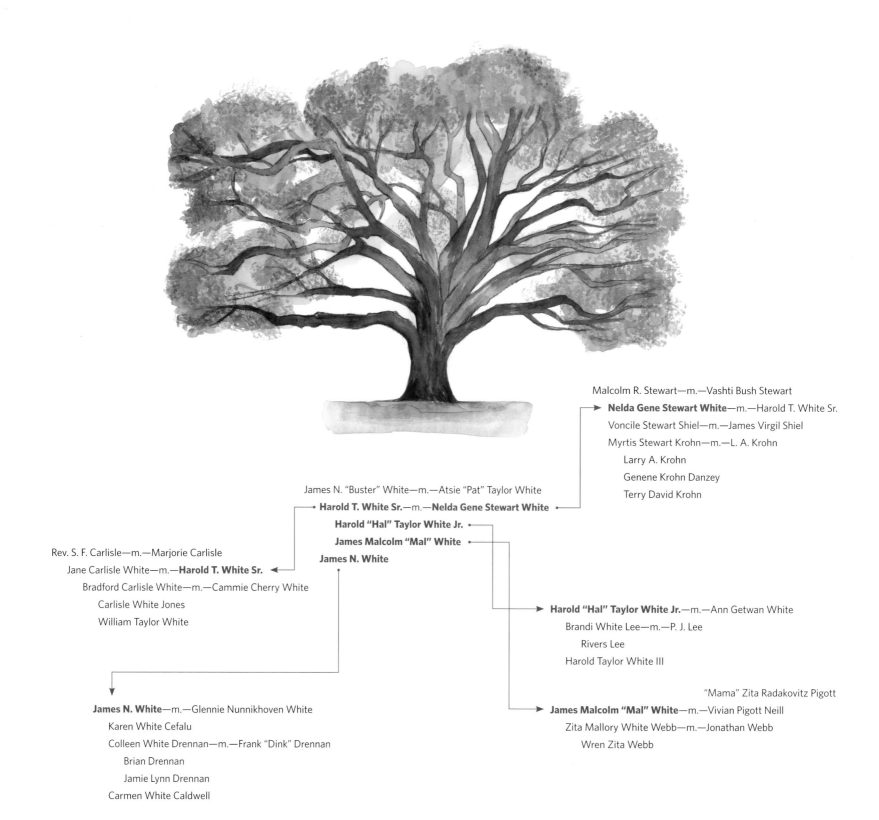

Malcolm R. Stewart—m.—Vashti Bush Stewart
Nelda Gene Stewart White—m.—Harold T. White Sr.
Voncile Stewart Shiel—m.—James Virgil Shiel
Myrtis Stewart Krohn—m.—L. A. Krohn
Larry A. Krohn
Genene Krohn Danzey
Terry David Krohn

James N. "Buster" White—m.—Atsie "Pat" Taylor White
Harold T. White Sr.—m.—**Nelda Gene Stewart White**
Harold "Hal" Taylor White Jr.
James Malcolm "Mal" White
James N. White

Rev. S. F. Carlisle—m.—Marjorie Carlisle
Jane Carlisle White—m.—**Harold T. White Sr.**
Bradford Carlisle White—m.—Cammie Cherry White
Carlisle White Jones
William Taylor White

Harold "Hal" Taylor White Jr.—m.—Ann Getwan White
Brandi White Lee—m.—P. J. Lee
Rivers Lee
Harold Taylor White III

"Mama" Zita Radakovitz Pigott
James Malcolm "Mal" White—m.—Vivian Pigott Neill
Zita Mallory White Webb—m.—Jonathan Webb
Wren Zita Webb

James N. White—m.—Glennie Nunnikhoven White
Karen White Cefalu
Colleen White Drennan—m.—Frank "Dink" Drennan
Brian Drennan
Jamie Lynn Drennan
Carmen White Caldwell

THE ARTFUL EVOLUTION OF
HAL & MAL'S

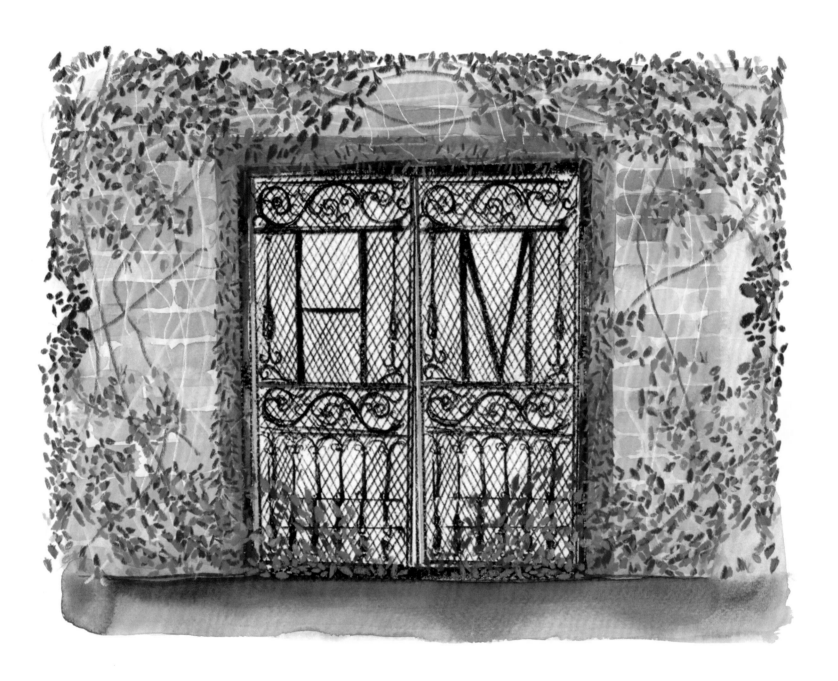

Iron gates to courtyard by Pat
Pigott and vignette small vines

THE VIGNETTE COURTYARD

In our town, founded where French Canadian Louis LeFleur set up his trading post (approximately where the WLBT television station sits today) around the turn of the nineteenth century, we sometimes forget our story. LeFleur chose the location because of its strategic overview of the bend in the Pearl River; the like-minded entrepreneurs, trappers, and traders who had clustered there; and the large population of Native Americans and others who passed through the spot. In addition, LeFleur's Bluff, as it is now known, was relatively close to the World Wide Web of the day—aka the Devil's Backbone or the Natchez Trace, the region's economic and transportation lifeline. The city of Jackson blossomed over the next century, and in 1927, the GM&O Freight Depot opened on Commerce Street. Fast-forward another fifty years, and the grand old warehouse was sitting abandoned and derelict when Hal and I came along looking for a place to establish a cultural outpost—a gathering place for comunity, art, and good food. Hal and I tackled the thirty-two-thousand-square-foot structure section by section, as resources and energy allowed. When we opened in 1985, the only functioning spaces were the Dining Room/Pub and the Big Room, often referred to as the Amish Dance Hall by our longtime tenant and beloved resident painter, Richard Kelso. The Oyster Bar came next, and around 1989, the Courtyard. Later, we opened the Neon Fish, sometimes known as the Red Room and at one point the home of Soulshine Pizza; in between, other art studios and living quarters occupied this funky brick establishment.

The French word *vignette* means "small vine." Historically, a vignette was a decorative design or small illustration—branches, leaves, grapes, or the like—used on the title page of a book, at the beginning or end of a chapter, or to separate sections of a book. It has also come to mean a short but graceful literary sketch, usually between eight hundred and one thousand words.

I like to think that *vignette* aptly describes the French-style Courtyard at Hal & Mal's, which has a small vine-draped entryway over a heavy, black wrought-iron gate bearing the initials H and M. The vine was planted in a small sliver of soil by Mama Zita

more than two decades ago and has grown to cover the entire south end of the building, an addition constructed to serve as a refrigerated storage room for the Merchants Company, which occupied the building after the GM&O vacated. The iron gate was built by Zita's youngest son, Pat Pigott, who has done many other fencing and ironwork projects for us over the years. When our family got the lease on the building in 1983, the roof on this section of the building had collapsed, leaving it open to the sky. We decided that it would be easier and more interesting to create a courtyard than to try to rebuild the roof and reclaim the space for interior use.

We knew from our New Orleans years that the open-air space would be perfect for alfresco dining and drinking, a wonderful complement to the concert spaces, dance hall, and pub in our rambling complex. We had always loved the courtyards at the French Quarter's Old Coffeepot Restaurant, established in 1894 at 714 Saint Peter Street, just around the corner from where we worked at the historic Bourbon Orleans Hotel, and at Mary Mahoney's Old French House in Biloxi. The Coffeepot offers great Creole fare, particularly Calas Cakes (fried rice balls), which are best enjoyed in the restaurant's classic small courtyard dining room. We often slipped over there on our breaks from the Bourbon Orleans.

Some of our earliest childhood memories feature Mary Mahoney's Old French House, which was both intoxicating and familiar. Entering the complex that houses the restaurant requires passage through an exotic, moss-draped courtyard that captured our imaginations early on, as did the outbuildings. Our dad would take us along when the Mississippi community and junior college presidents gathered there for annual conferences and cocktail parties. Dressed in elaborate, flowing gowns and butterfly-shaped eyeglasses, Miss Mary Mahoney would entertain us with her remarkable stories. She was the consummate hostess—in the words of her son, Bobby, although she had no college degree, she "majored in social endeavors." According to Bobby, every Sunday, his father, Robert Sr., would go to the newsstand to pick up a copy of the *New York Times* so that Mary could keep up with developments in food, art, and culture. Her skills played an enormous part in making the Old French House Biloxi's culinary and social epicenter.

So we created this "little vine" courtyard to embrace the complex mixture and influences that led us to create the global gumbo that is Hal and Mal's—the French heritage of LeFleur, the melting pot of the Mississippi Gulf Coast, and the cosmopolitan eccentricities of New Orleans. And fittingly, this vignette includes 818 words. ■

GM&O

Just for the record, the building that houses Hal & Mal's is currently owned by the State of Mississippi. We have leased it for more than thirty-five years, and I figure that we have paid the state about a million dollars in rent so far and spent well over half a million dollars more to make the place inhabitable. In the late 1970s, a group of investors had signed a fifteen-year lease and planned a major multiuse development. But they were unable to raise the money they needed and happily signed the lease over to us in 1982. The original lease document had been signed by Governor Cliff Finch (1976–80). The structure was built in 1927 to serve the freight depot for the Gulf, Mobile & Northern Railroad (GM&N). Just north of us is another old building that was also constructed in 1927 to serve the passenger depot for the GM&N and New Orleans Great Northern Railroad. Those two lines merged during the 1930s, and in 1940, the GM&N and Mobile & Ohio combined to become the Gulf Mobile & Ohio Railroad (GM&O). Until 1954, when passenger service ended, the other building, known as the Old GM&O

Depot, served as the railway's passenger depot. The State of Mississippi purchased that building in 1982, and it is now occupied by the Mississippi Department of Archives and History.

As far as I've been able to determine, our building served as the freight depot from 1927 until the Merchants Food Company leased the space in 1935. Now known as Merchants Foodservice, the company originated in Hattiesburg in 1904, when seven stockholders opened the Fain Grocery Company to service central Mississippi's retail and wholesale grocery trade. The name changed to the Merchants Grocery Company three years later, and the company expanded to Laurel, Vicksburg, and Jackson. Within a couple of years of moving into the warehouse, Merchants outgrew the one-story building and expanded by adding a second story to the building. A GM&N engineer, Louis Philip Oechsle Exley (1878–1957), figured out how to jack up the roof, construct the second floor, and then set the roof back down atop the newly laid bricks without damaging a single shingle. The Merchants Company consolidated its operations in the 1970s

and moved south down Commerce Street. Merchants' "Big M" logo is still faintly visible on the north end of the building.

The building's original address was 617 East Pearl Street. Construction of the interstate eliminated this stretch of Pearl Street, replacing it with the Pearl Street Exit from I-55 to State Street at the foot of the Old Capitol Museum. Somewhere along the way, the state purchased the building, intending to use it to house an agriculture museum. Ultimately, however, the Jim Buck Ross Museum was built out on Lakeland Drive instead, and the old depot sat mostly empty until the unsuccessful late-1970s attempt to develop it. When we arrived on Commerce Street, the only occupant of the thirty-two-thousand-square-foot structure was Bright Image, a lighting and costume business operated by Bruce Ingebretsen. The rest of the building was completely empty, without electricity or running water. Dark.

When my partners and I got the lease, our big idea was to develop the space into a bar and restaurant. We started by moving in the Lamar, a college beer bar open only on Wednesdays and Saturdays that had been located in the old Lamar Theater on Lamar Street until the Jackson Redevelopment Authority razed that building and replaced it with One Jackson Place. The Lamar limped along until the passage of the National Minimum Drinking Age Act in 1986.

Mississippi and alcohol have long had an odd relationship. The state had no minimum legal drinking age prior to 1920, when the Eighteenth Amendment to the US Constitution ushered in the Prohibition era. Prohibition was repealed thirteen years later and the drinking age was set at eighteen, but Mississippi continued to ban the sale of alcohol. Nevertheless, in 1944, the state instituted a 10 percent tax on alcohol sales, creating a paradoxical situation in which the state was taxing something that was illegal. Not until 1966 did the Mississippi legislature end the statewide ban on alcohol sales and allow counties to determine their own policies.

The 1986 US law required all states to raise the drinking age to twenty-one or lose federal highway funds, and all states complied. With the legislation pending, we saw the handwriting on the wall, and in late 1985 we began hosting music acts and special events that appealed to an older audience—Albert King, the Bluebeats, the Bluz Boys, Lazy Day, Mitch Ryder (without the Detroit Wheels), Marcia Ball, and Mitch Woods & His Rocket 88's. We also hosted a number of special events, among them Black Tie Christmas and the 1985 Mal's St. Paddy's Parade, and a few Millsaps College frat parties.

In 1985, we hosted our first street concert, Deadbroke Blues & BBQ, as a fund-raiser for Bluesman Sammy Myers, who had run afoul of the tax man. The show featured Anson Funderburgh & the Rockets, Fingers Taylor, the Tangents, Romin' Hands, These Days with Jewel Bass, and several other local bands. The whole affair was emceed by Michael "The Rube" Rubenstein and featured ribs by *Clarion-Ledger* writer Raad Cawthon. Orley Hood and Bill Nichols served as executive producers and oversaw the construction of the stage along with our resident carpenter, Nick, and his able assistants, Sleepy and Orlando. My dad drove down from Booneville to support the cause, and Mama Zita sold tickets and T-shirts. Phil Abernethy

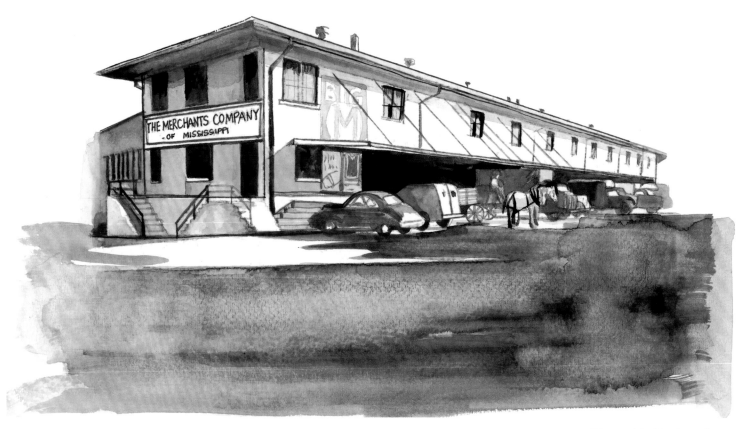

Old view of the Merchants Company
with horse-drawn cart out front

represented the partnership, and Jill Conner Browne (of Sweet Potato Queens fame) walked around all day wearing a pink wig and a sandwich sign that read, "Don't Forget Raad's Ribs—$3." Vivian quietly managed the whole affair behind the scenes. David Patterson and John Hamrick provided the logistics and construction expertise in building the site. Walker's Drive-In, George Street Grocery, and CS's had food booths. We arranged it so that when the Rube introduced Sam and invited him to the stage to join Anson and company, he was delivered to the platform in a police car with blue lights flashing and sirens blaring. Despite the cold and rainy weather, we raised enough money to keep Sammy out of the grip of the authorities, persuading them

that he was more likely to pay off the rest of his debt if he was out of jail and working.

In the months before the drinking age was raised, we held several going-out-of-business parties for the Lamar, and through December 1985 and January 1986, we worked around the clock to get the kitchen finished. On January 8 (Elvis's birthday), we served our first meal as Hal & Mal: the guest was one of our upstairs arts tenants, actor, director, and writer John Maxwell, who enjoyed a roast beef po-boy. Hubert Worley captured that iconic moment for us.

Ironically, the National Minimum Drinking Age Act had given birth to Hal & Mal's. ■

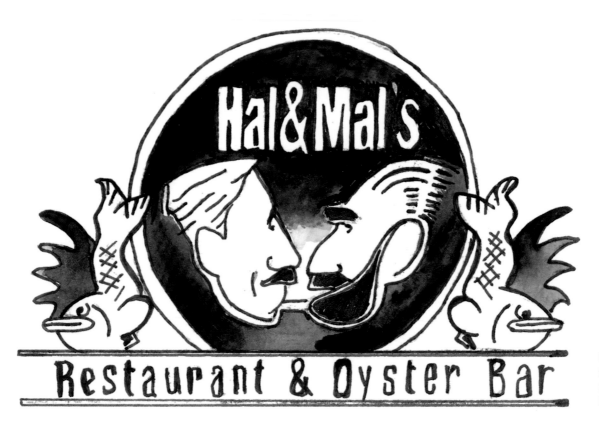

First logo with fish that mimicked Smith Brothers (Trade/Mark) Cough Drops

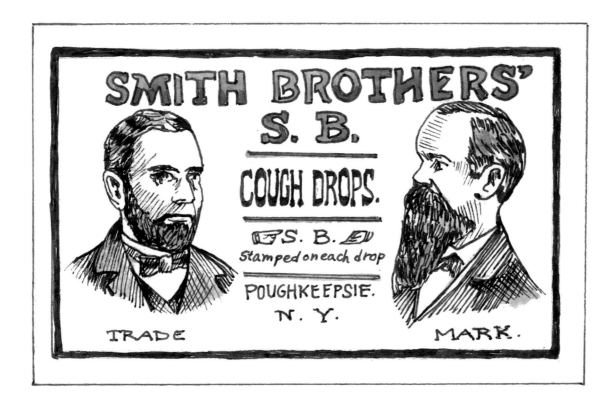

SMITH BROTHERS

Having decided to pursue our lifelong dream of opening a restaurant and bar, my brother and I needed a name and a logo. My wife at the time, Vivian, suggested we use our childhood nicknames, and voilà—Hal & Mal's. I had always liked the old-fashioned Smith Brothers Cough Drops logo, which features profiles of the two bearded brothers facing each other. Both Hal & I had experimented with facial hair, though our old man, Harold White, absolutely *hated* facial hair and long hair on men. I had to get two haircuts and hairspray my hair back before he would approve of my appearance for graduation from Northeast Community College, of which he was the president. He did not want me looking ragged and unkempt as I crossed the stage so that he could hand me my diploma. But after we moved out of our dad's house, Hal and I tried full beards, goatees, Fu Manchus, handlebars, soul patches, muttonchops, and everything else we could imagine. So I liked the idea of us mimicking the Smith Brothers logo. Over the years, Hap and Hilda Owen and Communication Arts Company have managed our branding and advertising. The late great David Adcock (Toons till Two), who worked for Communication Arts, was a talented and thoughtful designer who drew some of the earliest versions of our faces, while Ed "Chip" Millet, Justin Schultz, Ginger Williams Cook, and even a few computer programs have subsequently had their way with us.

William and Andrew Smith were the sons of James Smith, a Scotsman who moved first to Canada and in 1847 to Poughkeepsie, New York, where he established an ice cream parlor. (Who knew? I should have figured that my choice of a logo would somehow involve a restaurant.) James was a good carpenter but was even better at making candy and running a business. He bought the formula for a "cough candy" that was both effective and good-tasting from Sly Hawkins, a traveling patent medicine salesman; brewed up a batch on his kitchen stove; and with the help of his sons, who assisted with making and selling the drops, soon found success. The firm placed its first advertisement in a Poughkeepsie newspaper in 1852, inviting all "afflicted with hoarseness, cough or colds" to try the drops.

James Smith died in 1866, and his sons inherited the company, which officially became known as Smith Brothers. As sales grew, a crop of imitators began to sprout, among them the "Schmitt Brothers," "Smythe Sisters," and even other "Smith Brothers." William and Andrew, who by this time had long, flowing beards, decided to deter the competition by placing their faces on their product packaging. When they trademarked the image, the word *Trade* appeared under the photo of William, and the word *Mark* appeared under Andrew's image. The Smith Brothers thus became known to generations of Americans as Trade and Mark. Our logo features the words *Hal & Mal's* over caricatures of our (hirsute) faces; underneath, it simply says *The Brothers*. ∎

SAUCE OF LIFE

Both Hal and I were born at the old Methodist Hospital in Hattiesburg, Mississippi, when Harry Truman was president and Fielding L. Wright (Hal) and Hugh L. White (me) were governors of Mississippi. Our Baptist parents were living in Perkinston, which meant they had to choose whether to have their babies delivered in Protestant Hattiesburg or on the Catholic Gulf Coast. They went north. Both Hal and I lived in Hattiesburg at different times in our lives: we were fierce business competitors there, saw each other fall in and out of love, and shared various Piney Woods dwellings.

In the mid-twentieth century, Perkinston was a hamlet of a few hundred loggers, merchants, and college employees at the northern lip of the coastal plain, down in a geographic valley between Wiggins and Ten Mile Hill. We grew up living in Stone Hall, at the top of the sandy loam on which the campus was built and next to A. L. May Memorial Stadium, where our dad worked. A grove of longleaf pines surrounded the football field where we played and camped out on weekends. Our aunt was the campus nurse, our uncle was the business manager, and the members of the staff were as much our extended family as they were co-workers. Stone Hall was the athletic dorm, and our dad's coaching duties included serving as the live-in supervisor there. We were also responsible for doing the football laundry and keeping the dressing rooms and concession stands clean and stocked for game day. Dad, Mom, Hal, and I shared the rambling two-story brick complex with approximately seventy young men between the ages of eighteen and twenty years old. Each floor had a large military-style bathroom. We lived upstairs in a two-bedroom apartment with winter heat provided by tall radiators and summer cooling provided by windows that opened onto a small grove of live oak trees. Our mom occasionally made dinner in the little efficiency kitchen, but we ate most of our meals in the basement cafeteria. Not until much later did we realize that most people do not spend their adolescences surrounded by young, hungry, testosterone-fueled jocks with a food-service facility in the basement. That cafeteria is where we first met chef

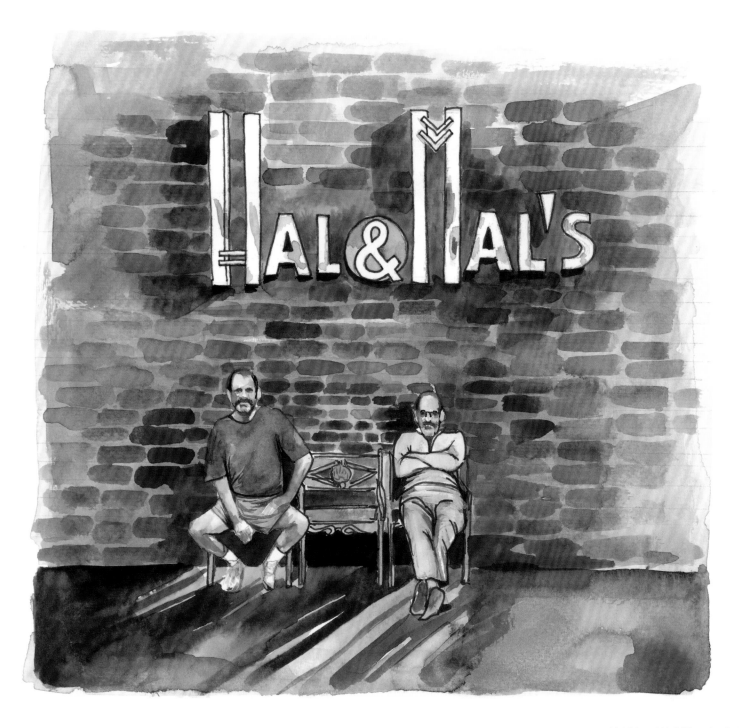

Hal (L) and Mal (R) under the iconic courtyard sign fashioned from old Lamar Theater letters by Ed Millet

Thelma Andrews, and we stuck pretty close to him as long as we lived on the Perk Campus. I cannot tell you how many grown men have since approached me and introduced themselves as former students and football players who lived in Stone Hall and babysat for Hal and me.

Around 1953, our family was upgraded to a small house across the street from the old gym. Half brick and half asbestos, with shingle siding, this house was where our mother died of malignant melanoma in 1954. Hal was five; I was three. We grieved and regrouped and managed as best we could. Our maternal grandparents, Mama and Papa Stewart, came to live with us during the school year; in the summers, we went the five miles to stay with them in Wiggins, a journey we came to know by heart. Hal and I traveled with Papa Stewart, the regional health inspector, as he made his rounds to every dairy, hotel, and public eatery from Hattiesburg to the Gulf Coast. We thus received early exposure to the back of the house of hotels and restaurants, and we were fascinated by their mysterious operations and cast of characters.

We continued living in that house until the summer of 1965, when we moved far, far north to Booneville. Our father brought his new wife, Jane Carlisle White, into that house in 1958, and in December 1959, we met our new brother, Bradford Carlisle White, there. In hindsight, I believe that the college moved us into the house because of my mother's illness—she needed peace and quiet and privacy that were unavailable in a dormitory full of young men. I remember her trying to be strong but becoming weaker with every passing day, but I was too young to really understand her suffering and her impending death, for which I am grateful.

We became known as "Coach White's boys, Hal and Mal," and sports, scouts, school, and our little wooden Baptist church kept us connected to family, friends, and community. We swam in Red Creek, built forts, and earned money to spend at Dees General Store by picking up empty drink bottles and catching amphibians for the science professor. Our uncle was the butcher at Dees; after we traded our bicycles for driver's licenses, we discovered that he also worked as a bartender on the weekends at Toot & Tell It. On Homecoming weekends, the men dug a long, narrow ditch, built a hardy hardwood fire, and burned the logs down to fine coals for barbecuing pork shoulders, sides of beef, and chickens. We stayed up all night to tend the fire and mop the meat as it slow-cooked, and we cooked hundreds of pounds of shrimp to serve the visiting faithful. The shrimp were boiled in a salty courtbouillon (pronounced *koo-bee-yon*) and then immediately poured over crushed ice to keep until they were peeled and dipped into our special sauce. Our favorite ritual was making the sauce, which featured a mayonnaise and ketchup base, lemon, Crystal hot sauce, salt and pepper, and Worcestershire sauce, which Hal and I always loved. Worcestershire sauce was created in the 1830s by British chemists John Wheeley Lea and William Henry Perrins, who were attempting to re-create a sauce that a local nobleman had discovered in India. After their concoction proved disappointing, the barrels were set aside and forgotten. When they were rediscovered

months later, the brew had fermented and mellowed. And now we have the Lea & Perrins company.

Hal and I began experimenting with making sauces when we were very young. We made sandwich spreads, seafood dipping sauce, salad dressing—sauces for every occasion. We never met a condiment we didn't like. "Special sauce" or "pink sauce" was our dressing for salads and seafood, and we later discovered that by adding a bunch of garlic and a few tweaks here and there, it became Comeback Sauce. We have made and sold enough sauce to fill a swimming pool. A large one. ■

MY BROTHER THE AMPERSAND

The ampersand is the logogram representing the conjunction *and*. The symbol originated as the ligature of the word *et*, which is Latin for *and*. For the purposes of this story, the ampersand represents my brother, Brad, as in "Hal & [Brad] Mal's." I long thought our name was misconjugated, but I was misinformed because (1) nouns aren't conjugated, verbs are, and (2) the rule is that in the case of a compound possessive, the apostrophe is added only to the second name. So there! Regardless, it's water under the bridge.

By the time Hal and I got around to realizing our lifelong dream, Brad was firmly ensconced in the Franklin, Tennessee, life into which he married. The union was an Ole Miss marriage that resulted in him joining the Cherry family and the Cherry family business, Mid State Automotive. But all Brad ever really wanted to do was coach, like his (our) father, Harold "War Daddy" White. After Mid State, Brad got that opportunity at Battlefield Academy in Franklin, where his kids attended and excelled in sports. Unlike our dad, with his martial, highly macho coaching style, Brad was a motivator, a touchy-feely kind of coach. He was ultimately fired because he refused to stop being his fun-loving and nurturing self. It was Battlefield's loss.

Today, Brad is in the food business, working with another successful Cherry family enterprise, Bear Creek Farms, which raises high-quality organic meat products and provides them to the very best Nashville restaurants. Brad is part farmer and part food-service provider. But at his core, he's a coach, a great dad, and an Ole Miss fan. Hal and I played junior college football, but Brad was a widely recruited athlete who ended up playing football at Ole Miss for Coach Steve Sloan. To this day, Brad and I have season tickets for Ole Miss football. Hal was a Mississippi State man, while I attended Ole Miss, Mississippi State, and Southern Miss. Brad and I started attending Ole Miss home games after Hal died in 2013. Before that, the three of us attended New Orleans Saints games together, and once we attended an Ole Miss–State game at Vaught-Hemingway Stadium. It was a really bad idea, even though I sat between my brothers. Late in

Hal, Brad (ampersand), and Mal at
Carlisle and Adam Jones's wedding

the second quarter, with Ole Miss handily whipping the Bulldogs, Hal announced, "I'm getting outta here. These people are getting on my last nerve. Y'all can stay if you want to." But we all left together, found our cousins Dink and Colleen Drennan tailgating in front of Barnard Observatory, and blended in there with the well-stocked assortment of Capital City adult-beverage products to soothe Hal's nerves and bolster Brad's celebration. I had quit drinking alcohol by this point, so I just sat back; grabbed a plate of barbecued pork, a bowl of banana pudding, and four deviled eggs; and watched the pageantry of SEC football unfold. Hotty Toddy, Hail State, and pass the hot sauce, please.

Brad comes home to Mississippi often and reminds his kids, Carlisle and W.T., that they are Mississippians by their dad's birth and Tennesseans by their mother's choice of where to live after Ole Miss. Carlisle often reminds Brad that Tennessee has better barbecue than Mississippi, and W.T. often reminds Carlisle that Mississippi is the home of Barq's Root Beer and where their parents met, fell in love, and first made a home. Brad reminds them all that he was far and away the best athlete in the White family, that he will always be the best-looking brother, and that he, like Prince, is often simply known by a symbol—the ampersand formerly known as their coach. ■

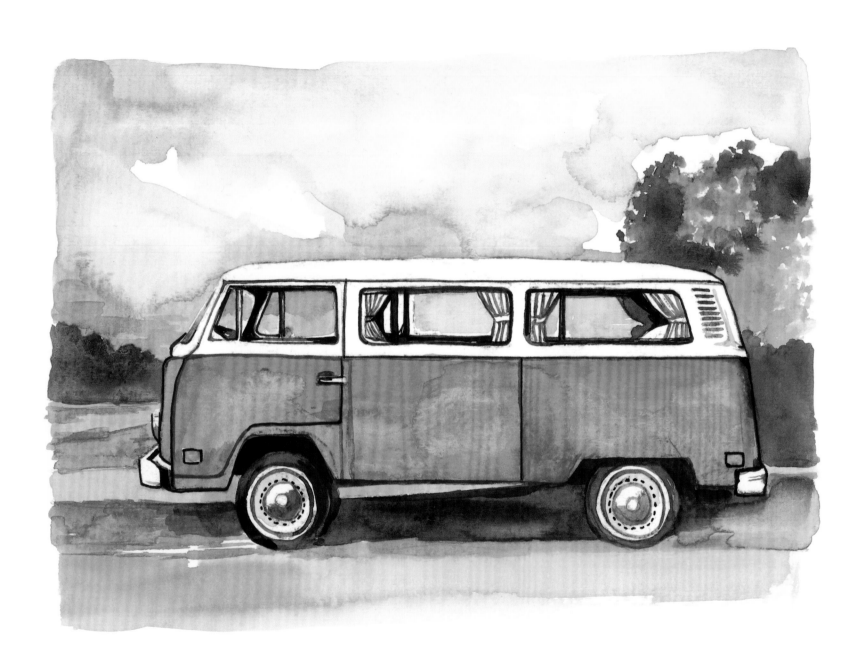

Mal's 1971 VW van with custom
curtains sewn by Vashti Stewart

GRANDMOTHERS & AUNTS

In this land, good cooks are more often called *grandmother* than *gourmand*, and our history paints a clear tradition of dining in the home long before we were comfortable dining in public. I cannot point to one singular impression that made Hal and me so certain that someday we wanted to open and operate a family establishment, but numerous people, places, and memories collectively nudged us in this direction. Prominent on that list are our Grandfather Stewart, the health inspector; chef Thelma Andrews; hunts and barbecues hosted by the men in our community; homecomings and church dinners; celebratory, empathetic, and conciliatory occasions of weddings, reunions, and funerals; and the great influence of America's very first celebrity chef/gourmand and food writer, Craig Claiborne of Sunflower County. Like Claiborne, Hal and I were raised in a melee of family gatherings, community cooking, and the impressionable boardinghouse experience, where, like Mr. Claiborne, we learned the virtues of the kitchen craft at the hem of a maternal family apron. In my humble opinion, three people have

changed the way Americans eat, cook, and think about food: Julia Child, James Beard, and Craig Claiborne. Hal & Mal's might not even exist without this bold and inventive trinity. When I was living in California, I realized that Muddy Waters, Howlin' Wolf, Mose Allison, and Delaney Bramlett were from Mississippi, and that knowledge transformed me. In much the same way, when I was living in New Orleans, discovering that Craig Claiborne was from Mississippi gave me a great sense of pride and place in the conversation about American culture.

The White brothers, including the ampersand formerly known as Brad (see "My Brother the Ampersand"), were blessed with not two but three of the finest grandwomen who ever drew God's good breath. On my mother's side was Vashti Bush "Mama" Stewart, a small, gentle saint. She raised not only her three daughters but Hal and me along with the various members of our extended family who for whatever reason or circumstance gravitated toward her always-open and gracious home for comfort, support, and nourishment. She cooked creatively using

meager provisions, often adding more love than exotic seasonings, and set a traditional Sunday table of roast beef, rice and gravy, potato salad, fresh garden vegetables, deviled eggs, and the very best pecan pie to ever grace a tablecloth. Her husband and my namesake, Malcolm R. Stewart, was a church deacon, a gifted kitchen collaborator, and a master hunter-gatherer. He was adept in slow food long before the movement was imagined, and he gathered crops, fish, and game so that we could eat locally year-round. We canned, preserved, and froze foods throughout the spring and summer and ate strawberries, silver queen corn, and peaches in December as well as snapper, bass, and bream all winter long. We picked and prepared pecans and shelled peas for the months when the land was idle. The table was always set for company, and friends and family would often stop unannounced to join us for lunch or supper, knowing that extra chairs were never more than a few feet away.

At the age of nine, I met my step-grandmother, Marjorie "Mama" Carlisle, a short, portly, preacher's wife who produced fine robust meals for her twelve children and whoever else placed their feet under her table. She made magic of humble yard chickens and the thick stands of turnip, collard, and mustard greens that surrounded their modest home in rural Covington County. This simple frame house served as headquarters for family gatherings that sprawled across the lawn to the old oak shade tree and into the nearby woods. These weekend-long reunions began with buttered biscuits at daybreak on Saturday and ended with pound cake on Sunday night, pausing only at midday on the Sabbath for church, where my step-grandfather, the Reverend Summerfield F. Carlisle Sr., presided and then gave thanks for our bountiful blessings.

In 1973, Hal announced his engagement to his high school sweetheart, Marilyn Carter, and we realized that Grandmothers Stewart and Carlisle had not yet met. I was tasked with getting them together before the wedding. The arrangements were made: I would pick up Grandmother Stewart in Wiggins and Grandmother Carlisle in Collins, and then we would mosey up the Natchez Trace north of Jackson toward Booneville, where we would rendezvous with the rest of the family. But we would need a meal along the way. I packed a picnic lunch of fried chicken, pimiento cheese sandwiches, and deviled eggs, along with assorted plates, utensils, and napkins. We must have been a most curious sight, a long-haired, bearded young man driving two proper, elderly women in a VW van with homemade curtains. In my head, I can hear the Beach Boys singing, "Go Granny, Go Granny, Go Granny Go." We drove about an hour up the Trace, I picked out a nice shady spot and spread out the blanket, and we sat down to have our lunch on the ground. I wish I had a photo of that moment: both grandmothers, meeting for the first time, chatting away about the upcoming wedding, the glories of the Lord, and how the food I had lovingly prepared was just right. After washing the food down with ample iced tea (of course), we got back on the road and reached Booneville around twilight, by which time the two venerable ladies had become not just friends but family.

My paternal grandmother, Atsie Taylor White, universally known as Pat, hand-rolled dumplings and cut them newspaper-thin

before gently casting them upon an ocean of bubbling, perfectly seasoned chicken broth. Her dumplings were meticulous and precise—consistently more geometrical than the woodcuts my grandfather produced on his prized miter box saw. (Her handiwork also got a whole lot more attention and praise than his did.) No one—and I do mean *no one*—was allowed to remove the lid of the ancient black dumpling pot and stir the sacred concoction lest they break her delicate creations and muck up the balance between chicken, broth, and dumpling. Later in life, I came to understand her views on the subject. Grandmother Pat stood firmly over the chicken and dumplings, the bread pudding pies, the boxcar lima beans with ham, and a cornucopia of other luscious dishes until her dying day and was the absolute (though benevolent) monarch of a most revered kitchen. Actually, it's surprising that any of us learned to cook, as she would not allow us to help in the preparations and often shooed us from the kitchen during the hours leading up to a meal. But the aromas emanating from the kitchen were irresistible, so we risked the consequences for a peek at or a taste of what was to come. This woman was one fine cook, small business operator, and entrepreneur. A sometime single mother who also housed and cared for her beloved but hopelessly alcoholic brother, Pat ran Bell South's telephone collections service out of her front room and took in boarders in the extra bedroom. In the yard was a persimmon tree that was heavy and sweet with fruit all summer long and provided a favorite spot for industrious honey bees. My grandfather, James Noel "Buster" White, was absent more often than not during most of my childhood, but he was lovable and kind and quite the

character when he was around. A restless sort, Buster knew that although they were divorced, Pat would always take him back, and indeed, he came home for his final rest. He was fond of saying, "The only good eating outside Pat's house is at revivals, fish fries, and funerals, 'cause it takes the whole town cooking to get a meal as good as your grandmother's."

The Sunday ritual when I was a child involved going to church and then loading up in the car and driving the five miles north to Wiggins for an all-day visit with my grandparents. First stop was Mama and Papa Stewart's for a lunch of roast beef or fried chicken. Then we would head over to visit Uncle James, Aunt Glennie (Pat's daughter-in-law), and our three exotic girl cousins, Karen, Colleen, and Carmen. We would spend the afternoon frolicking about their vast yard; lounging on their side porch, complete with ping-pong table; and exploring their very feminine rooms, where I was first began to contemplate the differences between young men and young women. These visitations often included homemade ice cream, pies, and/or fresh-baked cookies from Glennie's amazing kitchen. Glennie was of Dutch ancestry, and her family owned a store on Pine Hill, the main downtown business thoroughfare. She, too, was a brilliant cook. Our Sundays always concluded at Grandmother Pat's. Sometimes, her brother, Uncle Donnie Taylor, would be around drinking black coffee and smoking filterless Pall Malls, most likely recovering from a drinking spree or getting healthy enough for the next one. Donnie was a kind, brilliant man of simple needs. He could take an outboard motor apart and reassemble it like a surgeon, but once he drank a couple of beers, he

would inevitably end up at the county line on a stool at Toot & Tell It or Monk and Joe's.

Glennie carried on her mother-in-law's cooking traditions until old age got the best of her. At that point, Glennie took off her apron, sold the old place, and announced that her meatballs and spaghetti, bread pudding, chicken and dumplings, and pork chops were behind her. She was completely retiring from home-making and thenceforth expected to be waited on and cared for by her children.

All our grandmothers and aunts are gone now, leaving just us cousins. As children, we don't realize that grandmothers and aunts are ephemeral, that these amazing humans are time-limited. We are lulled into thinking that they are permanent, that they will always be there to love us unconditionally, to fuss over us, to pick us up when we fall, and to feed us our favorite dishes. In our case, these great women were not just our family but also our foodways mentors, and perhaps what they taught us inspired us to want to share. And as societal norms changed, we wanted to share not just with our family but also with the public. Maybe what we learned was the gift of giving, a way to enhance the community and memorialize those who went before us. ■

Craig Claiborne

BOONEVILLE BEGINNINGS

When I was a mean teen of fifteen and my brother, Hal, was all of seventeen, we moved from the cozy coastal confines of Stone County to the northeast hills of Booneville, in the tail of the Appalachian Mountains. Neither of us had ever heard of the place. Our disheveled and bewildered family arrived late at night, took a room at the Town Motel, and awoke to a good breakfast at the bustling attached restaurant. Our meager belongings, lovingly transported by Morgan Moving & Storage, were delayed in transit, so we spent several nights at the motel. We later learned that the restaurant was the social hub of the community—where families dined after church, special occasions were celebrated, and locals gathered for coffee several times a day to discuss news, sports, and what-all was going on in Memphis and to a lesser degree in Jackson. We also quickly learned the other cultural outposts—Feldman's Department Store, Tigrett's Drug Store and fountain, and Red's Drive-In (also known as Jack Sprat's) and the Campus Drive-In, both owned by local entrepreneur Red Vandevander. Jack Sprat's was where I enjoyed my first forkful of a delicacy known locally as a heated honeybun—a standard store-bought cinnamon roll doused in butter and placed on the hot flattop grill until golden brown. For an extra dime, it came with a dollop of ice cream. The other motel in town, the Reese Court and Restaurant, featured what we later understood was Comeback Sauce, which was available on every table in a plastic squirt bottle. It was *the* dressing for your salad or to top your meat-and-three special. This establishment was directly across Highway 45 from the town's true heart, a service station owned by Mr. Guy, known locally as Fatty, though the kind and benevolent man was short and stout but certainly not fat. Years later, I was told that local juvenile delinquents had transformed his original nickname, Daddy (as in Daddy Guy) into the more entertaining Fatty Guy. The station was also known as Guy's 45. Downtown Booneville was vibrant, with the highway running right down the middle and separating the high school, the town, and the college. To the north were Corinth and then Memphis, to the south was Tupelo, in the west

were New Albany and Oxford, and to the east-northeast were Tennessee and Pickwick Lake, the aquatic and recreational equal to the Gulf of Mexico in our former home along the coast. In these hillbilly parts, the locals read the *Memphis Commercial Appeal* and the *Tupelo Journal*, with the *Clarion-Ledger/Jackson Daily News* as an afterthought. Growing up on the Coast, we read the *Daily Herald*, which for many years as a child I thought was referring to my father Harold as somehow being involved in the publication.

After our first (but certainly not our last) Town Motel breakfast, which included a few introductions, we were off to tour our new home, the campus of Northeast Mississippi Junior College. As we made our way from town, we entered the campus and drove up and down Cunningham Boulevard. Hal and I looked at each other in the backseat and sarcastically wondered, "Where's the college?" But our new house was cool—a massive ranch-style structure in which we would no longer have to share a bedroom and would have our own private bathroom. We were golden.

The day after we moved in, the owners of the local newspaper, Mr. and Mrs. Johnson, dropped by to do a story on the new president of Northeast and his family. At the end of the visit, the Johnsons suggested that their two sons, who were close to us in age, come by later that night to pick us up and show us around town. My dad thought it was a wonderful idea and thanked them for their kind and neighborly gesture.

That night, we got a full indoctrination into Booneville. And early the next morning, the local police came knocking at the new president's front door. While Hal and I were sitting cluelessly in the backseat of the car, the Johnson boys had apparently tossed a garbage can lid through the storm door of the house occupied by a schoolteacher, Undine Smith. The incident earned us each a sound whipping and a lecture about ruining our father's career. We apologized, and Mrs. Smith eventually became my favorite high school teacher. One of my best memories is of presenting her with a signed copy of one of Willie Morris's books with an inscription praising her for nurturing my wandering spirit and supporting my interest in words and language.

A decade later, this peculiar hill country had become part of our DNA. Both Hal and I graduated from high school and played football for legendary Coach Jim Drewry, and later for Northeast Coach Bill Ward, supporting our father's dream of bringing football, a marching band, and campus life to this heretofore commuter college. We were coast rats for sure, but we learned to love the Appalachian terrain; the wood smoke of barbecue, coleslaw, and sizzling slugburgers; the tawdry backstreets of Memphis; Goat Island, Tishomingo, J. P. Coleman, and the region's other parks; and above all the people. On a recent Veterans Day Weekend, my old Booneville Blue Devil friend and longtime restaurant collaborator Tom O. Massey and I stayed at Coleman State Park—my first visit there in forty-five years. As we walked the park grounds and shared stories, memories drifted in the autumn wind, across the vast lake, and through the burnt-orange and russet-red leaves. Then we came upon the still water in a cove off Indian Creek, where the old camp store and marina were just where I remembered them, still standing, though barely. Once bustling and prosperous but now idle and deserted,

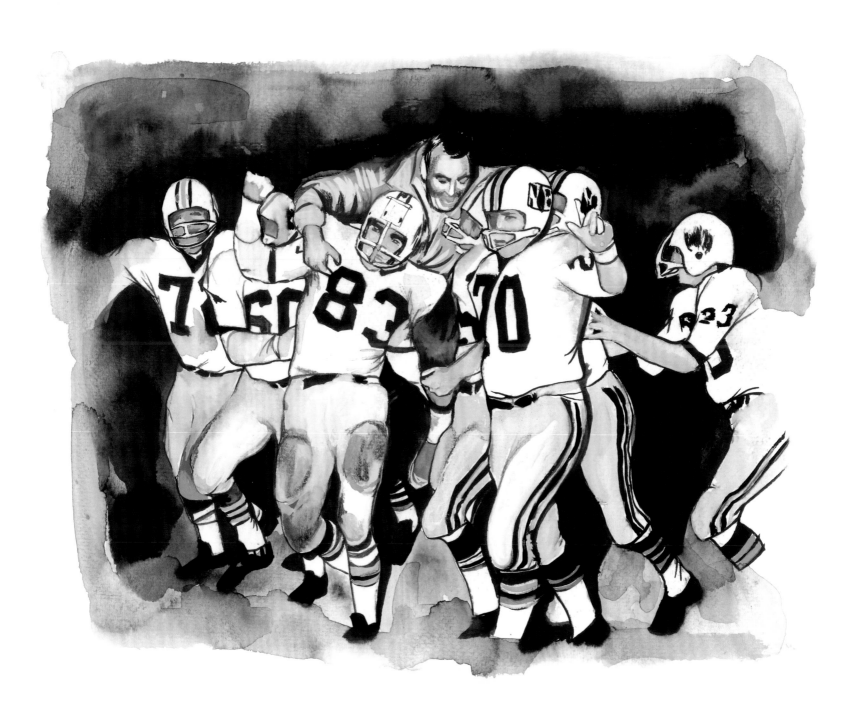

Coach Bill Ward being hoisted
after Northeast Tigers' victory
over Mississippi Gulf Coast
Community College. Mal is #83.

the structures evoked my memories of the mid-1960s, when we kept our boat at Coleman for several summers and often rented one of the old cabins on long weekends like this. Hal and I procured fuel, ice, and picnic supplies at the camp store on many ski adventure weekends with family members and later peers and girlfriends. I could almost hear Hal and his buddies unloading the car and prepping the boat for launch and feel myself gliding out across Pickwick Lake, in and out of the Tennessee River, and around historic Goat Island before heading for a swim at the waterfall. Recalling those youthful, seemingly frivolous days in this natural place warmed me despite the late-autumn chill.

This was where I met my first Jew, my first Mormon, and my first openly gay person and was the site of my first confrontation/attempt at racial integration. My friendship with John Michael Rubenstein began here and ultimately led me to join him in Jackson in 1979. Others I met here included Bill Barnett, Keith Kelly, Donna Green, Kay Finch, Phil Abernethy, Riley, Bob and Sandra Presley, Bill Breedlove, Rick Reinbold, Tom Massey, Kenny "Snatch" Whitley, Coach and Edna Drewry, the Langstons, the Floyds, Martha Ann Wright, Willie and Diane Weeks, David and Jane Cousar, the Newborn girls, the Godwin family, Travis Childers, Mike Cunningham, Kenny "Skinny" McKinney, Tommy "Moon" Cadle, Bill "Stewball" Stennett, Eddie Young, Joe Rowland, Jerry "Big Al" Allen, John "Manley" Hanley, Commodore Perry "Bird" Barrett, the Shackelfords, the Rutherfords, the Galloways, Kenneth Christian, Barb Volrath, Debbie Waters, Debbie Green, the LeCroy sisters, Doc Gullett, Mayor Marion Smith, the Steens, the Feldmans, Ted Rubenstein, Marshall Dickerson, Connie "Bob" Mooney, Benny Hamilton, Mac McAnally, Big Earl and Little Earl, Donna Cunningham, Tommy "Bardo" Barden, Mattie May Williams, Genie Ray Frazier, Gary and Judy Frazier, Woodsie, RayAnn Woodruff, Ann and Buddy Whisenant, Coach Ken, the Lindseys, Bob Franks, Piggy Bonds, the Cavers, Elta and the Ellzeys, Bruce Browning, Mrs. Voncannon, Hudson "Hud" Hickman, Jettie Nunley, Willie D. Jumper, the Jumpers of Jumpertown, the Hugheses, the Austs, Jan Rubenstein, Charlie Gillespie, Freddie Tollison, Louis Rone, Kenneth Holditch, Bill Cunningham, Butch Caldwell, Mike and Don Guy, Jama Davis, Danny Vail, Steve Mac Nabors, Chief W. W. Stacy, Ann Ross, Lois Farrar, William "Frog" Walden, Carl Loden, Mrs. Melton, Mr. Tutor, and of course our resident bootlegger, Harold Lloyd Brinkley. I fully expect that sooner rather than later, I will run into someone at the doctor's office or the grocery store and they'll say, "Hey, Mal, I noticed you didn't put my name in that book. Thanks a lot, you Phinx"—a reference to our favorite local band in those days.

I slowly transitioned away from Booneville beginning in 1971—first to Mississippi State with Hal; then back to Wiggins; then on to Clinton, Oxford, California, Hattiesburg, New Orleans, and Hattiesburg again. I was restless and curious, adventurous and often adrift. But when I wasn't drifting, Jane, my stepmother, welcomed me home, and my dad always found me a job on the college maintenance crew—painting, doing carpentry and electrical repairs, working on the fleet of vehicles, cutting the grass, hanging sheetrock, sandblasting, and cleaning the campus. But Hal's exodus was more dramatic. The morning after his going-away

party, the headline in *Booneville Banner-Independent* read, "29 Jailed in Raid." Prentiss County's Walking Tall–style sheriff, Roy "Big Iron" Elder, was determined to put the bootleggers out of business and keep the local young people unsullied and under control. As young longhairs who drank beer in a dry county, Hal and his buddies had gotten on the radar of the Sheriff's Office. According to Sheriff's Department officials, the house at 111 College Street had been under surveillance for three weeks, and the raid, which took place at around ten o'clock on a Friday evening, had resulted in arrests on charges of gambling and possession of whiskey and beer. Most of those arrested were minors. And with that, Hal put Booneville in his rearview mirror. ■

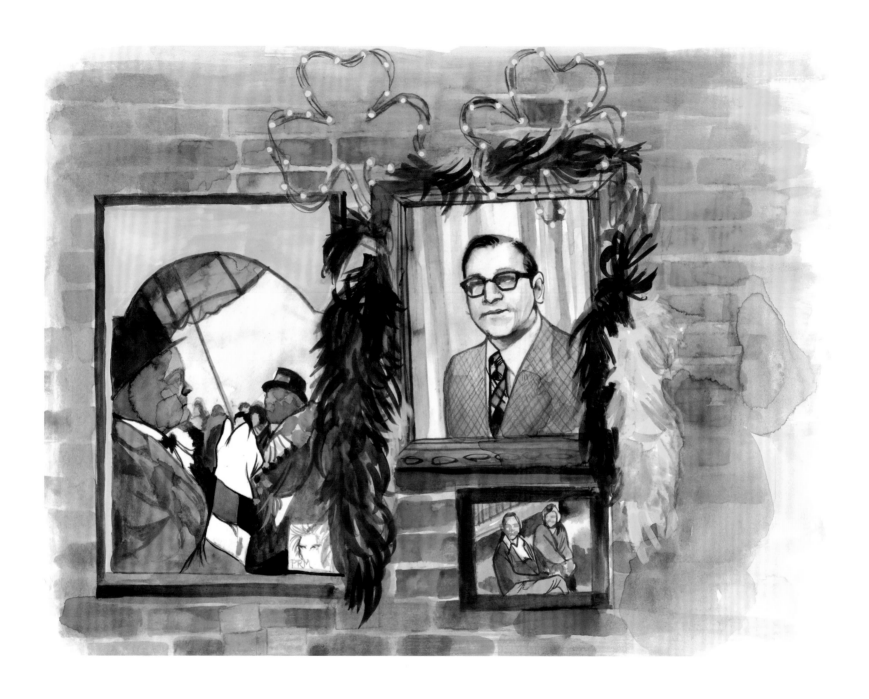

Foyer wall featuring portrait of Harold T. White, a Jazz Fest poster, and a photo of H. T. and Mama Zita taken at the Deadbroke Blues and BBQ

DADDY'S LAST VISIT

My father, Harold Taylor White Sr., was born on May 27, 1924, to Atsie Taylor "Pat" White and James Noel "Buster" White Sr. of Wiggins, Mississippi. He graduated from Wiggins High School in May 1942 and enrolled at Perkinston Junior College the following September. In June 1943, after his freshman year, he enlisted in Army Air Corps, becoming Sergeant Harold White, aviation mechanic. He trained in Florida, North Carolina, and Connecticut as well as at Gulfport Field before being stationed in Lake Charles, Louisiana. After World War II ended, he reenrolled at Perk on February 8, 1946, and he graduated on May 28, 1947. He served as an assistant football coach at Perk from August 1, 1951, until June 30, 1952. He also taught at Perkinston Agricultural High School, where he coached boys' and girls' sports, winning the South Division Championship in girls' basketball in 1952 and 1953. "War Daddy" White became the high school's head football coach in 1952. In keeping with his nickname, his coaching style resembled military training: according to his former players, he would have them lie on their backs and hold their feet six inches off the ground, and then he would put on a pair of hightop cleats and walk across their stomachs. H.T. left coaching in January 1957 to become athletic director at Perkinston Junior College, a post he held until June 1961. He was subsequently promoted to dean and then assistant to the president before leaving Perk to assume the presidency of Northeast Mississippi Junior College in Booneville. He was still serving as president when he died in 1987, though he took a leave of absence in 1972 to move to Jackson and serve as Governor Bill Waller's federal-state coordinator.

My father was driven and hardworking. His philosophy of life was formed in his early years—his father was often absent from the family—and in the military. Our mother died in 1954, when he was in his early thirties, and he spent the next four years working, going to school at night, and doing his best to raise two young boys. He married Jane Carlisle on September 5, 1958, at the chapel on the Perkinston Campus, and they had a son, Bradford Carlisle White, in December 1959. Brad later got in trouble

when he and two of our lifelong friends, Perry and Beth Sansing, reenacted that wedding in the chapel just hours after the college maintenance staff had refinished the wood floors. Having ruined the varnish, all three kids got good old-fashioned spankings from their parents—and blamed the others for coming up with the caper.

My dad was delighted when Hal and I finally opened the restaurant. He loaned (gave) us five thousand dollars to get us started and often tried to give his north Mississippi friends and associates, including former Speaker of the Mississippi House Billy McCoy, money to have lunch at Hal & Mal's when they were in Jackson. (The representative refused the money but always made a point of patronizing our establishment, spending hours sitting with Hal at the Willie Morris table in the corner, catching up on all things Booneville, Harold White, and "Northeast.") There is a portrait of my dad in the foyer of the restaurant that once hung in the entryway of White Hall, a men's dormitory on the Northeast Mississippi Junior College campus that was named in his honor. I had the privilege of living in that dorm during my last year at Northeast, when I played football for Coach Bill Ward. The photograph disappeared mysteriously from the dorm foyer and was missing for years until I received an unexpected phone call from an old girlfriend. As a Northeast student, she had had a rather complicated relationship with President White, and for whatever reason, she had stolen the photograph. Did I want it? Yes, I did. With due respect to Northeast, it now resides in its rightful place.

On August 26, 1987, Daddy was in Jackson for some Northeast business and to attend a rally on behalf of gubernatorial candidate Jack Reed. After the rally, he came by the restaurant. As was often the case in those days, Hal had worked the early shift and gone home, so he wasn't there, but Daddy and I visited for a while. He had an untreated heart condition that had long nagged at him, but as a rule, he suffered silently. That night, however, he felt bad enough that he mentioned to me that he wasn't feeling well. He said he wasn't very hungry, but I offered him a bottle of Cutty Sark Scotch whiskey to take back to his hotel room for a nightcap. He agreed but insisted on paying for it; I managed to talk him out of it by explaining that our liquor license did not permit us to sell full bottles of liquor. As he said good night, he tried one last time to convince me to support Reed over Ray Mabus in the governor's race.

Dad went back to his favorite room (fourth floor, right next to the pool) at the Edison Walthall Hotel on Capitol Street. Our family had stayed at this hotel what seemed like a million times, through countless changes of name, ownership, and management, and Daddy had not only a favorite room but also a favorite table in the restaurant and a favorite bartender. He was a creature of habit. That night, he returned to his room, changed into this pajamas, turned on the news, poured himself a Scotch and water, and started calling his politician friends who were running for office across the state. After speaking with Senator Jack Gordon of Okolona, who was in a hotly contested reelection race, Daddy sat down in front of the TV and took a sip of his drink. At that moment, his heart stopped beating. He did not struggle; he simply passed from this earth into the arms of his maker. The next day, during the lunch rush at Hal & Mal's, two Jackson Police

Department officers came in and asked to speak to me. We went into the office, and after asking if Harold T. White was my father, they told me as gently as they could that he had died during the night and that I needed to come with them to identify the body. Before I could do that, of course, I had to go into the kitchen and get Hal, bring him into the office, and break the news to him. Those words were some of the most difficult I have ever spoken. We cried and hugged, and then we got into the cop car for the drive to the hotel. Though the distance was less than a mile, it was one of the longest rides of my life, silent and sorrowful. We were, of course, intimately familiar with the room. We entered and saw our father—our hero, our rock—in his favorite away-from-home chair. He was sitting upright as if nothing at all was out of order. His glasses were still on, the drink was still in his hand, but he was gone. I asked the officers to leave so that Hal and I could have a last moment with our dad. We called Brad, and I again uttered those difficult words.

Daddy was buried on the side of a clay hill in Woodlawn Cemetery in Wiggins, Mississippi, along with my mother, Nelda Gene; my stepmother, Jane, who died in 1982; his brother; his parents; and other beloved family members. I had the honor of penning his epitaph: "A Friend of Man—A Man of God." ■

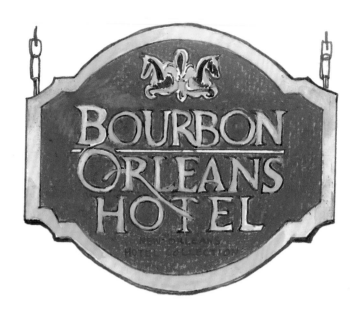

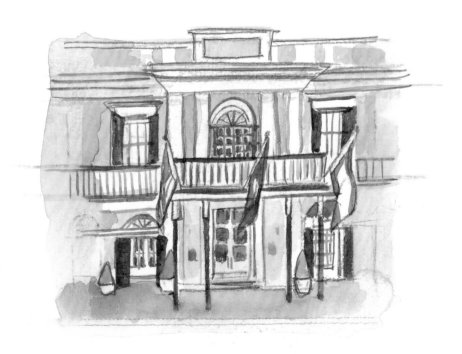

Sign and front entrance
of the Bourbon Orleans
Hotel, New Orleans

THE BOURBON ORLEANS

In 1974, I moved from California back to Mississippi, enrolled at the University of Southern Mississippi, and took a job as a dishwasher at E.J.'s Restaurant in the Ramada Inn on the north side of Hattiesburg. My cousin, Mike Carlisle, worked there and put in a good word for me—not that being a dishwasher really required a good word. Before that gig, I worked at a health club, another job Mike secured for me, but it simply was not my thing. But at E.J.'s, as dishwashers go, I excelled, and I was quickly promoted to cook. John Sawyer, the hard-driving property manager, noticed my zeal and work ethic and summoned me into his office for a chat. He started by asking if I liked the restaurant business. When I said, "Sure," he responded, "Good. Go back to the kitchen and fire the chef. Then you will become the chef." Mr. Sawyer was an intense and strange dude. I asked, "You mean the guy who trained me?" "Exactly!" he exclaimed.

When I followed his instructions, the chef laughed at first. Then I told him, "Go ask Mr. Sawyer if you don't believe me," and tied on my apron and started chopping onions and peppers for the gumbo. He did, and I never saw him again. I put on the tall, white paper hat and got to work. When hostess Jan Powell entered the kitchen to begin the shift, she grinned at me and said, "Hello, Chef." Obviously, the word was out. "You got this," Jan said. Her young daughter, Lisa, who often came to work with Jan, giggled and gave me a wink. The girl grew up to become Lisa Mills, a highly successful singer and musician who has performed at Hal & Mal's. Six months later, Sawyer called me back into his office and again asked if I liked the business. This time, I became the assistant manager of the hotel and restaurant.

One person who was working his way through college as a bartender at E.J.'s was Jay Dean—now *Dr.* Jay Dean, the conductor of the USM Orchestra, producer of Festival South, and artistic director of the Mississippi Opera. We again work together regularly, this time with the Mississippi Arts Commission. But we both got our hospitality (and maybe arts) start in Hattiesburg working for Mike Carlisle.

After I had been the assistant manager for about six months, Mr. Sawyer asked if I wanted to move to New Orleans and work at a sister property, the Bourbon Orleans Hotel in the French Quarter. I pointed out that I was enrolled in school and it was the middle of the quarter. "I didn't ask about your college life; I asked if you wanted a real job." I asked to have the weekend to think about it and talk to my adviser, but Mr. Sawyer would have none of it: "I don't think you understand. This isn't a college internship. I need a *yes* or a *no*. If you leave this office without a decision, I'll offer the job to someone else."

A week later, I was assistant general manager of the Bourbon Orleans Hotel and living in "Chilly" Gentilly on Chef Menteur Highway (US Highway 90). This road, like the remarkable city I now called home, had a strange and beguiling story. Chef Menteur (Lying Chief) was reputedly the Choctaw Indian name for a colonial French governor who reneged on a treaty.

The ragtag hotel staff greeted me with suspicion: I was just some twenty-four-year-old kid who showed up from Mississippi to run the show. And they didn't even know how limited my inexperience truly was. I soon came up with a strategy: I recruited my friends and family to help me. The first to join the team was Kenny "Snatch" Whitley, an old friend from Booneville who had waited tables and bartended in Dallas before joining me in NOLA. We initially shared a room out on Chef Menteur Highway before we both moved into town. Hal arrived shortly thereafter and waited tables in the dining room and worked banquets. Danny Sommers, who worked with me at the Ramada Inn in Hattiesburg, soon arrived to tend bar. Mr. Brown, the old German GM, fondly referred to us as the Mississippi Mafia.

When we weren't working hard to run the hotel, banquets, and in-house restaurants and bars, we spent our money and time in Buster Holmes's, Tipitina's, Rosie's, Casamento's, Lu and Charlie's, Mandina's, Mosca's, Pascal's Manale Restaurant, Buffa's Lounge, the Half Moon Bar, Papa Rosetti's, the Coffeepot, and other restaurants. The atmosphere and food of all of these places influenced our thinking about how a local gathering place should look, smell, and feel. But those years and life lessons would not have been possible if John Sawyer and Mike Carlisle had not pushed, prodded, and put in a good word for their young dishwasher.

By 1977, we had all left the Bourbon Orleans. Danny stayed in New Orleans and opened the Café Savanna on Oak Street, which instantly became an Uptown staple. Whitley, too, stayed and worked with Danny and later for the upstart House of Blues. Hal and I came home to Mississippi. ■

THE POLITICS OF KETCHUP

Any administration foolish enough to call ketchup
a vegetable cannot be expected to cut the mustard.

—John Glenn, 1981

It's been called a vegetable by government officials, sent into outer space, and proudly served at the Waldorf Astoria Hotel. It's the noble ketchup, and it's been the foundation of many a condiment of the American South.

I don't own stock in any company that makes ketchup, but perhaps in retrospect, I should have had the foresight to buy some early in life. However, the very first money I earned was as a teenager picking cucumbers for the Brown-Miller factory in Wiggins, which was then the largest pickle operation in the country. While pickles seem to be a fashionable condiment these days, ketchup is ubiquitous—seemingly mandatory on every table in every restaurant, café, or diner across America. I sure should have seen this coming.

As a child, I often ordered fried shrimp when we stopped to eat during our frequent travels. I recall specifically a meal at one of my dad's very favorite roadside eateries, the Wagon Wheel, owned and operated by the Koch family just south of Hattiesburg. This establishment was famous for its barbecued ribs and fresh baked demiloaves of bread. The ribs were excellent, and I ate them until the place closed. But on this particular occasion, I ordered fried shrimp. My dad was astonished: "Fried shrimp? This is a barbecue restaurant, Son, not a seafood place." I explained that I understood, but on that day, I felt like shrimp. He shook his head in disgust but let me have the shrimp and ordered his ribs. Whatever his personal opinions, he was similarly supportive when we were in a restaurant and I asked for ketchup but the establishment did not stock it. (Back in those days, it was much less ubiquitous.) "You don't have ketchup?" my father would retort. "Hell, they serve ketchup at the Waldorf Astoria." I never understood how that helped the situation in Lucedale, but I was a kid and what do kids know? The point

was, my dad had been to New York's most famous hotel dining room and was reporting to folks along the Mississippi byways that ketchup was coming and they better get ready.

In the early years of Hal & Mal's, we had a beloved customer, Oogie Carlson, who lunched with us a couple of times a month, usually on Fridays for catfish. He rode his bike downtown and parked it out front. Oogie was always alone but was never interested in sitting at the bar, so he'd wait for a table. If Ann White was in the building, he insisted she wait on him. Ann has the patience of Job and spent extra time making sure that all of Oogie's requirements were met. He insisted on having a fresh bottle of ketchup with his meal—not one that had been opened previously or used by other customers. I get it.

In 2004, when John Kerry was the Democratic candidate for president, a movement sprung up in the Deep South to boycott Heinz ketchup because the good senator from Massachusetts was married to Teresa Heinz. However, the White brothers found the proposed substitute, Hunt's ketchup, inferior. There was no way that we were going to bypass Heinz in favor of the tomato-water known as Hunt's just because of silly politics. Ketchup is more important than that. As Hal said, "Screw Hunt's and the Restaurant Association; I wouldn't serve that crap if they gave it away. If we used Hunt's in our Comeback, it would run all over the plate looking for a low spot to hide in. We're a seafood restaurant. Nobody comes here for ribs." ■

Heinz, not Hunt's, Ketchup

FOUR GENERATIONS OF STRONG WOMEN

In 1930, young Zita Radakovitz, named for the last empress of Austria-Hungary, sailed to America in the belly of a big, lumbering, and miserable ship. Several years earlier, Zita's parents had left her and her brother, William, behind in Güttenbach, a village in eastern Austria about ten miles from the Hungarian border, and made their way across the ocean in search of a better life, and now they were finally ready to have their children join them in Chicago. But Zita had fallen ill just before they departed, and she ran a high fever during the voyage—so high that she had to be bathed in ice, which was a precious commodity on board the ship. The only other passengers who knew her name were William and the adults who were escorting the children across the ocean. Moreover, her parents had been gone so long that they were strangers to her. What an incredible leap of faith.

Zita Radakovitz reached Chicago; recovered from her illness; went to school; and married Jim Pigott, a handsome US soldier of Irish descent whom she met at a USO function. They had already begun a family in Chicago when Jim was presented a business opportunity in Jackson, Mississippi, and they headed south.

I met Zita's daughter, Vivian, in 1979, when I was managing Oliver's Restaurant in Highland Village and she was working at George Street Grocery. We both ended up employed at George Street and discovered we lived across from each other on Congress Street, just a few doors south of Eudora Welty's birthplace and across the street from Richard Ford's childhood home. Both Welty and Ford attended the neighborhood Davis School, and so did our daughter, Zita Mallory, a few years later. Our first home was the two-story Victorian-style house where Two Sisters Kitchen is today. Both the house and the New Capitol were built in 1903.

Chef Bobby Ginn ran an old-school boardinghouse eatery where patrons sat family style at large circular tables around lazy Susans heaped with fried chicken, butter beans, stewed okra and tomatoes, and all the other traditional Mississippi offerings. The historic old White House Restaurant was a cousin to the Mendenhall Hotel and the Dinner Bell in McComb,

venerable establishments that once populated the region. Dad rarely bypassed them as we made our way across the landscape of the American South. At least two such establishments—Peggy's Fried Chicken in Philadelphia and the Senator's Place in Cleveland—still exist, though the health department has sadly crimped the lazy Susan concept.

Later Bobby G's moved to the Hilton Hotel on State Street. That is where I met Mama Zita for the first time, when she was working at the gift shop for her dear friend Mildred Notaro, grandmother of Tig Notaro. From the gift shop, she went to work in the restaurant as a hostess for Bobby G. When we opened Hal & Mal's, she joined our enterprise. Mama Zita is and has been our moral compass; she quietly kept the peace, steadied the wheel, and smiled and greeted people no matter how much the world around her changed. Until her recent passing at age ninety-six, she would drive in from Madison County to work two days a week as a labor of love. Her memory represents the very best of what we set out to accomplish here: good sturdy food in a community gathering place dedicated to art and culture.

Though our establishment is named for two brothers, strong women have always been essential to the enterprise—managers, bartenders, cooks, and waitstaff. But the women in the family have played the greatest role. For the first decade, there were Mama Zita and her daughter, Vivian; after that, it was Mama Zita and Ann White; and now we have Zita Mallory and Brandi White Lee. For a while after Hal's death, we needed even more help from our family and friends, especially Zita Mallory and Taylor White.

Hal's granddaughter, Rivers Lee, and my granddaughter, Wren Zita Webb, are the fourth generation of women in the family to join our crew. On a good day, you can walk into Hal & Mal's and among the customers, family, and employees find as many as three Zitas plus Brandi, P.J., and Rivers, all going about the business of keeping the family business going. Hal and I did our part and P.J. is doing his, but credit for every success we have ever had at 200 South Commerce Street goes to the strong women in our family, especially Mama Zita, our matriarch and our saint of lost keys. ∎

Mama Zita, Zita Mallory,
Vivian, and Wren Zita

Mustard Sauce

(4) 2 c. Sour Cream
(1) 2 Tbl. Mustard (Pg)
(1) 2 Tbl. Creole Mustard
(2) 1 Tbl. Horseradish
(2) 1 Tbl. Season Salt
(2) 1 Tbl. Worcestershire
(2) 1 Tbl. Soy Sauce
(2) 1 Tbl. Lemon Juice
(4) 2 Tsp. Honey

Onion Soup

3 Lg. Onions
4 oz Butter → 4 oz Brown Sugar
1 Tbl. Worcestershire
1 clove garlic
1 Tsp. White Pepper
1 Tsp. Salt
2 c. Red wine
6 oz. Beef Base
+ gal. water
Dark Roux to thicken
or Corn Starch

Mustard sauce and
onion soup recipes

HAL'S RECIPE CARDS

I don't know where he got the idea to scribble his recipes on 4 × 6 index cards (as Willie Morris organized his writing notes), but from the very beginning, that's how Hal did it, binding them together with a big fat rubber band—one stack for soups, another for one-pot dishes such as gumbo and red beans, and a third for lunch or dinner entrees. He kept these giant stacks of cards in the upper-left-hand drawer of a metal desk in the office. Every morning, Hal was the first to arrive. He unlocked the doors, made a pot of coffee, and then went digging into the drawer. After choosing a soup and an entree for that day's specials, he would open the *Clarion-Ledger* to see what had occurred overnight and check on Mississippi State sports. He collected cookbooks, mostly for inspiration. He read them like most people read novels or nonfiction but rarely used the recipes. He loved to explore and experiment and was easy to shop for because there are always new cookbooks. He greatly admired Justin Wilson, Paul Prudhomme, Emeril Lagasse, and anything coastal, but he also had a taste for the eclectic, and I would bring him foodways books from wherever I traveled. Hal was a soup master: no cook or chef to ever stand behind a stove in Jackson could rival him in this department. He was simply the best, and anyone who tasted his soups knew it. He also had a knack for one-pot dishes, which he came by honestly. Grandfather Stewart cooked slumgullion (cleaning out the fridge) every week, and Grandmother Pat was known for her meatballs and spaghetti, pot roast, chicken and dumplings, and boxcar lima beans with ham. Plus, as the menus at Hal & Mal's note, our Aunt Myrtis was the Queen of Gumbo, at least in our world. We have always been willing to contribute food for fund-raisers and other local causes, and organizers often ask us to bring soup.

So when Hal died on March 28, 2013, after several long, painful days at St. Dominic's, I got in my car and drove to the restaurant, went into the office, and began to comb through his desk. It was exactly how he had left it—an apron, his knives, his chef shoes under the chair. I perused his memorabilia and the knickknacks above his shelf of cookbooks. And finally I opened

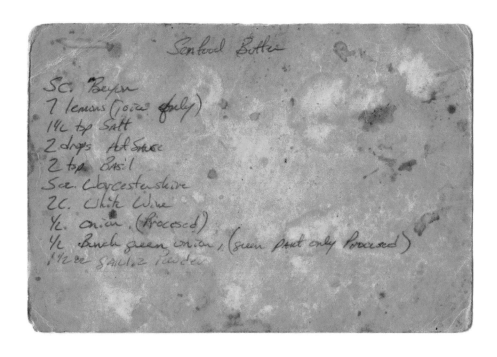

Seafood butter (for basting and side dish) and the legendary red beans

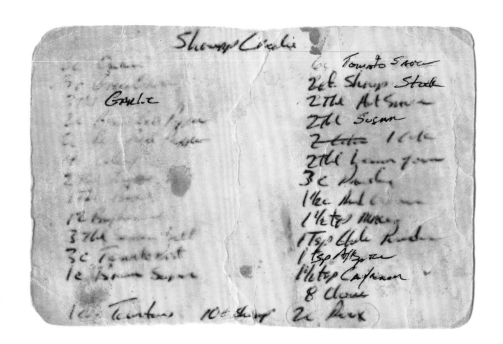

Shrimp nachos and shrimp creole. "We're a seafood restaurant." —Hal

Whiskey sauce for
bread pudding

his recipe drawer, slowly removed the rubber bands, and began to read his half-print, half-cursive writing on the stained and worn cards. They contained the art, the soul of this man, my older brother's last will and testament, his masterpiece, and they calmed me in this intense moment of grief and loss. Every time P. J. Lee, Flo, or Lela Courtney takes one of these pieces of folk art to the kitchen and turns on the stove under the pot, Hal remains with us; he nurtures, comforts, and feeds us with his inventions, his chosen herbs and spices. As his daughter, Brandi, says, "The smell in these cards captures the cooking bliss that was stained in all Dad's chef shirts and was embedded into all his hugs. That aroma calmed me on so many days and sustained our family, body and soul." The end result stands as his intentional allegro of giving: one cup of garlic, a cup and a half of cream, two hot peppers, three TBL basil, a pinch of cayenne pepper, parsley, rosemary, and thyme. The restaurant was closed, the office quiet. I smiled as I heard Hal's voice in my head, reading the ingredients and responding to my complaints about his heavy jalapeño hand with "Hell, that ain't hot! I took the seeds out of it!" ◼

THELMA ANDREWS

Chef Thelma Andrews was an important man in our community, in his community, and in my life and Hal's life. He was the first food-service professional we knew, and he demonstrated great courage and leadership in many other arenas far beyond the kitchen.

The Perry County native spent thirty-eight years—including the entire time that Hal and I spent on campus—cooking for the students of Perkinston Junior College (now the Perkinston Campus of the Mississippi Gulf Coast Community College). When he retired in 1970, Thelma received an honorary degree; ten years later, a building was named for him.

Chef Andrews honed his skills by studying dietary sciences at the Tuskegee Institute in the summers of 1937 and 1940 under Carl Wintz, a chef at New York City's Waldorf Hotel. While at Tuskegee, Thelma met and cooked for legendary botanist and inventor George Washington Carver, who published several volumes of recipes as part of his attempts to promote alternative crops such as peanuts and sweet potatoes. During World War II, Thelma served as a cook and assistant chaplain in the US Army.

Before coming home to south Mississippi, he worked at boardinghouses and hotels around the country.

In addition to being willing to oversee the college's massive food-service operation and make sure that the students, faculty, and staff were fed, Thelma was a superb teacher and mentor. He welcomed us into his kitchen and explained the workings of the giant Hobart mixers, commercial deep fryers, and towering baking ovens. All we had to do was wash our hands, mind our manners, and behave. On Saturday mornings, the steam tables in the college cafeteria would be piled high with eggs, bacon, sausage, biscuits, and milk gravy; one tray held stack after stack of perfectly grilled pancakes. Students would take three, four, or even six cakes at a time and adorn them with warm melted butter and heated maple syrup. When Thelma saw Hal and me coming (and a few others, especially the college president's oldest son, J. J. Hayden III), he would go back into the kitchen and bring out fresh hotcakes right off the griddle, providing a glorious start to the weekend for a bunch of raggedy country kids.

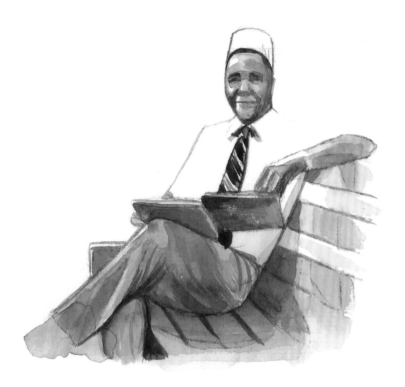

Mr. Thelma Andrews

Archivist Charles L. Sullivan, a great friend and the keeper of all Perk knowledge, recently showed me a news brief that appeared in the *Stone County Enterprise* on July 14, 1955. Headed "PJC Summer Students Entertained," the piece announced, "Students attending the summer session at Perkinston Junior College were entertained with an alfresco supper on the spacious back lawn at the home of President and Mrs. J. J. Hayden Jr. Head Chef Thelma Andrews presided at the barbecue pit." The president's house was directly across the street from ours: Hal and I could easily have attended the event with our dad.

In 2003, at the celebration of the centennial of Mississippi's New Capitol, Dr. David G. Sansing, professor emeritus of history at the University of Mississippi and our former neighbor in Perkinston, gave a remarkable speech:

> When we dedicated this building one hundred years ago, there were two men living in Mississippi whose lives are worthy of note. One you have probably never heard of, the other is one of Mississippi's favorite sons. One was a black man, born in obscurity deep in the Piney Woods of south Mississippi. The other was a white man, born on the northern edge of the Pontotoc Ridge, the son and grandson of prominent men.

The black man, Thelma Andrews, was a cook in a college cafeteria. At least that's how he started. He later became the Director of Food Services at Perkinston Junior College. He was a man of quiet dignity; there was something noble about him in his simple devotion to duty and in his goodness. In the 1960s after Perkinston was integrated he was a role model and mentor to students and faculty alike and in his own way he was as much a teacher as I was. Mr. Andrews, as far as I have been able to ascertain, was the first African American for whom a building was named on one of our traditionally white college campuses.

The white man, William Faulkner, has been acclaimed throughout the world for his literary genius. Faulkner produced some of the world's great literature and won every important literary award.

Thelma Andrews and William Faulkner did not know each other, yet their lives were ineradicably linked in that seamless flow of time we call history and they, with many others like them, built the New Mississippi. Andrews and Faulkner are typical of the goodness and the genius of our people.

We were indeed blessed to have known this man. ■

VONCILE & VIRGIL

Coach James Virgil Shiel was born and raised in the rural reaches of Wesson, Mississippi—specifically, on the banks of the Big Bahalia Creek, where Lawrence and Lincoln Counties meet. He and my Aunt Voncile met and married in south Mississippi but spent most of their adult lives teaching, gardening, hunting, and fishing in and around Ponchatoula, Louisiana. To be more precise, my uncle did most of the hunting and fishing, while Voncile held down the home front and her prolific kitchen when she wasn't teaching biology at the high school or at Southeastern Louisiana University in nearby Hammond. Voncile made an incredible dish that I institutionalized as Eggplant Voncile and put on the menu of Tuminello's in Vicksburg back in the early 1980s. The eggplant was peeled, sliced, breaded, and browned in olive oil before being topped with Mary Tuminello's red sauce and broiled in the oven with mozzarella, bread crumbs, and fresh chopped parsley. Mississippi Italian. Miss Mary gave me a copy of her spaghetti sauce and meatball recipe that I have framed and hanging in my kitchen at home. Chef Michael Barry and I were drilled on the precise technique and proper proportions for her sauce (a blend of hand-crushed tomatoes and basil, garlic, onions, and Progresso tomato paste) and her meatballs (pork, beef, bread crumbs, chopped garlic, parsley, and cheese). And if we heard it once, we heard it one thousand times: "Don't roll the meatballs! If you do, they become hard like brickbats. And keep your hands wet with water while you are forming the meatballs so they don't stick to your hands."

Uncle Virgil used to tell Mississippi folks that the reason he and Voncile moved to Ponchatoula was the existence of six very fishable rivers within an hour's drive of their house. I fished them all with him: the Tangipahoa, the Tickfaw, the Natalbany, the Tchefuncte, the Amite (he pronounced it *A'meet*), and the East Pass and West Pass, which connected Lakes Pontchartrain and Maurepas. When Hal and I lived in New Orleans in the mid-1970s, I kept my fishing boat in Voncile and Virgil's Ponchatoula yard. When we had a day off from the Bourbon Orleans, we drove up the road, hooked up the boat, and headed out for a

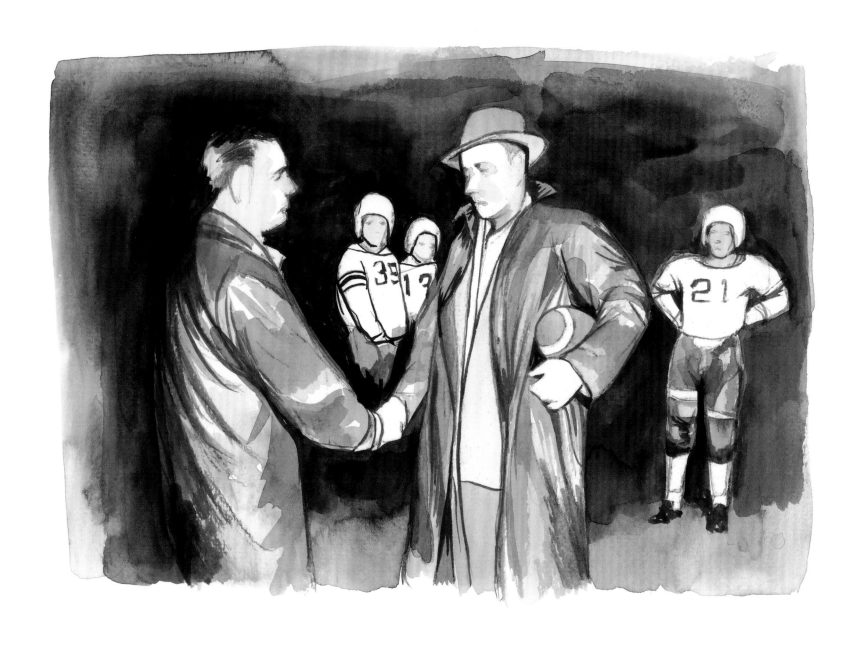

Harold T. White and Coach
Virgil Shiel at Dairy Bowl

day of fishing or crabbing or just touring around the swamps. At day's end, we would come back to a feast conjured up from the land and hands of our beloved aunt and uncle. On one such outing, we borrowed a dozen crab traps from one of Virgil's friends at Manchac and set them out in Lake Maurepas early one morning. After a long day of beer drinking, sunning ourselves, and checking crab traps, we were late getting back to the city, quite sunburned, and still a little buzzed. Unfortunately, Hal had to work a private party at the hotel. I dropped him and his waiter's uniform at the Bourbon Orleans and headed back to our apartment, where I promptly went to bed. Hal was a little irritated, but as I recall, he forgave me the next day over spicy boiled crabs and Dixie Beers.

Voncile and Virgil grew their own vegetables, and Virgil plowed with a mule until he was too feeble to work. He was a hunter-gatherer, and they were true farm-to-table pioneers long before the bearded and retro-hippie youth took up the cause. Our aunt and uncle always had fresh venison, fowl, locally raised meats, and veggies from their massive truck-patch garden a few miles out of town in the Pumpkin Center community.

In addition to being a teacher, Aunt Voncile volunteered with the local history museum. She was devoted to my uncle, to our family, and especially to us, "the boys." She came to our rescue after her sister—our mother—died at the age of twenty-nine. We spent many, many days entertained by her patient reading and singing of nursery rhymes. She made sure that we did not feel abandoned and that we spent quality time with family, and she provided us with feminine guidance during the fragile and uncertain years before our dad remarried.

Uncle Virgil was a coach, teacher, and outdoorsman. He took me bird hunting and gave me my first bird dog, whom I loved dearly but never really succeeded in training properly to hunt. Virgil served with the US Marine Corps during World War II, and he and my father (Virgil's brother-in-law) were members of what Tom Brokaw has described as the "greatest generation." My uncle, like my dad, was a football coach and later an educator and administrator. Both men brought what they had learned in the military to their coaching endeavors. Uncle Virgil was an outstanding football player at Wesson High School and later at Copiah-Lincoln Junior College before heading west to play for the University of Wyoming Cowboys. After college, he taught, mentored, and coached at Wiggins High School, Perkinston Agricultural High School, and Ponchatoula High School. A 1950s photo hanging in Hal & Mal's shows my dad, the athletic director at Perkinston Junior College, presenting Uncle Virgil with a trophy for coaching the winning team in the Dairy Bowl. I remember with great fondness and pride the first time Voncile and Virgil came to Hal & Mal's: "James Malcolm"—with the exception of my dad when he was angry with me, Uncle Virgil was the only person ever to call me by my full name—"you know you and Hal have made your old uncle proud today." They took a table and ordered two Aunt Voncile's Spicy Pimento Cheese and Bacon Sandwiches, though I think Uncle Virgil really wanted a hamburger steak with onions and gravy. ■

Mama Mosca

MAMA MOSCA

When Hal and I lived and worked in New Orleans in the mid-1970s, we often made the long drive over the Huey P. Long Bridge to the venerable Mosca's, a Creole Italian restaurant on a two-lane road in Avondale, Louisiana, about seventeen miles west of the French Quarter. Though I had a fear of the bridge, it was not a bad drive, though the trip back to the city could sometimes present a challenge after we'd enjoyed dinner—and drinks. Italian immigrant Provino Mosca and his wife, Lisa, opened the eatery in 1946 after migrating to the area from Chicago when their daughter, Mary, married Louisiana oysterman Vincent Marconi. At the time, the building that housed the restaurant was owned by Carlos Marcello, a New Orleans crime boss, who became a regular patron. More than seventy years later, the Moscas' descendants continue to operate the roadhouse, and Marcello's son still owns the building. My brothers and I are among those who regard it as one of New Orleans's best restaurants.

After Provino's death in 1962, Lisa (known as Mama Mosca), Mary, Vincent, and Johnny (Lisa and Provino's son) took over. When Hal and I went there, Mama Mosca was always standing in the doorway between the dining room and the kitchen, bigger than life and wrapped in a soiled white apron, inspecting each plate coming and going. I always made a point of telling her how much I enjoyed the dinner, and she always thanked me and invited us back, but talking with customers was never her thing. To us, she stood like a lighthouse over the rocky waters of the kitchen and the calm elegance of the simple yet welcoming dining room. Mama Mosca died in 1979. Hurricane Katrina walloped the restaurant in 2005, but it reopened the following year, mostly unchanged except for a larger, air-conditioned kitchen. Johnny's widow, Mary Jo Mosca, and their daughter, Lisa, now own and operate the restaurant.

My friends Raad and Karena Cawthon and Rickey and Liz Cleveland once had a dinner there that was so incredibly good

that when they finished, they asked the waitress to bring another round—the same exact meal all over again. They ordered another bottle of wine while they waited and then enjoyed part 2. The dinner lasted all night. One member of the Mosca family, Nicholas Mosca, is a dentist who serves as director of the STD/HIV Office of the Mississippi State Department of Health and is affiliate faculty at the University of Mississippi University Hospitals and Clinics. As a special gift, he once made us a pan of Oysters Mosca and delivered it to Hal & Mal's: we popped it in the oven and then feasted on one of God's great gastronomic creations.

On January 23, 1977, the *New Orleans Times-Picayune* ran a nice piece about Mosca's in its Sunday Lagniappe section. After reading it and sharing it with Hal out on our Royal Street balcony over coffee and sugar toast, I cut it out of the paper. Today, that yellowed clipping with its photo of Mama Mosca hangs in a frame in the foyer of Hal & Mal's, forever a reminder to us of what a family restaurant is. Customers sometimes ask me if that picture shows Mama Zita. Although it doesn't, I often associate the two Mamas—proud immigrants working with their families to serve a hungry public. ■

CALIFORNIA SANDWICH SHOP

Once when Hal was about seven years old and I was five, our grandparents took us to lunch at the old White Cap Restaurant. The waitress welcomed us and asked what we would like to drink. Without a moment of hesitation, Hal said he would have a Jax beer. The waitress and Mama and Papa Stewart, teetotalers both, were taken aback by this pronouncement. The waitress said, "I'm sorry, young man, but we don't have Jax beer." Hal pointed to a neon clock on the wall and retorted, "Yes, you do. It says right there on that sign you proudly serve Jax beer." He did not get the beverage he ordered that day, but he had more success ordering cold beer with his seafood gumbo on many later occasions.

Our maternal grandfather, Malcolm Stewart, was a Baptist deacon and the state health inspector responsible for all the hotels, motels, dairies, cafés, and restaurants from the California Sandwich Shop in Hattiesburg to the Sun-N-Sand Motel in Biloxi on the Gulf Coast. Hal and I grew up hanging out in kitchens, swimming pools, and dining rooms—Papa Stewart would drop us off at iconic eateries, like the Friendship House and the White Pillars, while he made his rounds. The California Sandwich Shop, built in 1912 at the corner of Front and Mobile Streets (where the Southbound Bagel and Coffee Shop is now), was one of his favorites. We would spend the day with the Vasselus family, whose members he not only trusted but also praised as exemplary restaurateurs, eating pressed po-boys while sitting in the old school desks in the dining area. In the foyer of Hal & Mal's is a photo from the cover of the February 1982 issue of *Mississippi Restaurateur* that shows my grandfather sitting at the counter of the California Sandwich Shop, having lunch and visiting with Paul Vasselus in front of a Jax beer sign. We would often sit outside on the sidewalk for hours and watch the trains come and go in the freight yard just across the street—perfect entertainment for two young boys. On the coast, we were free to eat all the shrimp and crabmeat we

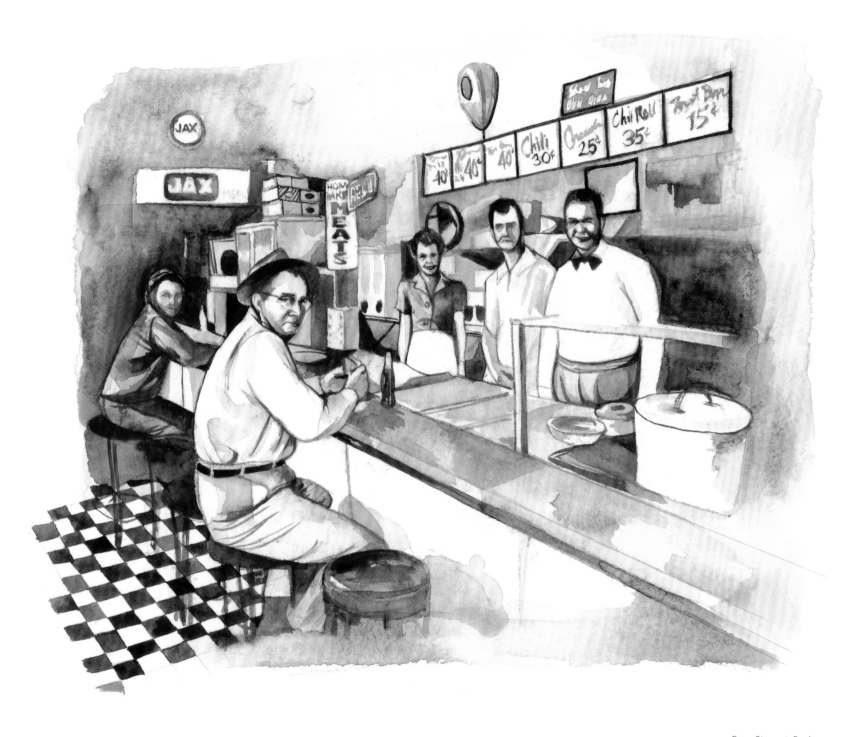

Papa Stewart, Paul
Vasselus, and family

wanted before swimming in the multilevel pool at the Broad-water Beach Hotel, where we could also order cheeseburgers and Barq's root beers at the in-water tables in the shallow end. Despite the death of our mother, Hal and I were lovingly cared for by our dad, our grandparents and other family members, and this extended network of restaurant folks. ■

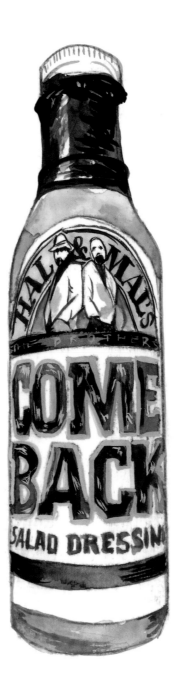

Our version of Comeback Sauce

COMEBACK SAUCE
(Come-Back, Kum-Bak, Kumback, Kumbak)

There are almost as many spellings for this uniquely Jackson salad dressing/dipping sauce as there are recipes and theories for its origin. Many observers trace the oddly orange concoction, consisting of a variety of ingredients that generally include mayonnaise, tomato ketchup, Worcestershire sauce, mustard, black pepper, chili sauce, lemon, and plenty of garlic, to Alex Dennery's Rotisserie Restaurant, located on US 49 at Five Points in Jackson. Recipes for "rotisserie dressing" (or sauce) are said to have originated directly from the restaurant.

The name is obviously a reference to the idea that people who try the zesty blend will always come back for more. Many native Jacksonians and visitors alike are fond of pouring the dressing over saltine crackers as a first course while waiting for the salad to arrive. Locals enjoy this "redneck hors d'oeuvre" so much that many restaurants will not put large bottles of sauce on the table

for fear that the entire bottle will be consumed before the salad arrives. In the early days of fine dining in Jackson, Greek immigrants dominated the kitchens and counters of the city's restaurant scene. According to Mike Kountouris of the Mayflower Café, language difficulties meant that young Greek immigrants could find work only in kitchens or as busboys. Comeback dressing may have been the Greek American answer to Thousand Island, the most popular salad dressing of the mid-twentieth century in the American South.

Paper records are scarce for such ephemeral matters as family-held salad dressing recipes, but oral histories point to Five Points in Jackson as the source of the spread. In 1936 Alex Dennery (born John Alexander Tounaris in Greece) supposedly was searching for a signature salad dressing for his newly remodeled property, the Rotisserie, at the intersection of Highway 49 and Livingston Road. A former drive-in movie theater, the Rotisserie occupied a unique location in southwest Jackson at the junction of five streets and featured a different entrance

This essay also appears as an entry in *The Mississippi Encyclopedia* (University Press of Mississippi, 2017).

on each street. According to Roy Milner, a longtime employee of the Dennery family, after staff tried and failed several times to concoct what Dennery wanted, Alex took to the kitchen and began experimenting. He first made mayonnaise by combining raw egg yolks with oil and then added chili sauce, garlic, and other ingredients. Dennery's Restaurant in downtown Jackson long served a version of the sauce, but hundreds of other variations have developed, among them the tangy Mayflower Café version, the smooth Crechale's rendition, a kicked-up version at Walker's Drive-In, and a super garlic version at my family's Hal & Mal's. But no matter where diners find this sauce, the empty bottle marks the spot where they will have to come back for more.

According to legend, writer Henry Miller so persistently demanded that Eudora Welty invite him to Jackson that she gave in and issued the invitation, though she hesitated because of Miller's reputation for extravagance. Miller arrived and announced—to Welty's dismay—that he would be staying for several days longer than she had intended. At a loss for ways to entertain her guest, Welty took him to the Rotisserie five times, each time entering the restaurant via a different door. On his final evening of copious eating and drinking, Miller noted approvingly that Jackson certainly had a large number of fine dining establishments for such a small town. The house dressing was undoubtedly one of the delights he sampled during his visits. ■

AUNT MYRTIS'S GUMBO

My mother, Nelda Gene, had two older sisters, Voncile and Myrtis. All of the Stewart sisters were raised in a big old house in Wiggins that their father had helped to craft. An outbuilding behind the house had been added to house Papa Bush, my grandmother's father, in his elder years, and after Papa Bush passed, Grandfather Stewart used the structure as a workshop, filled with his ancient tools and an overhead, handcrafted village for his beloved purple martins, who wintered in South America but returned each spring. Native Americans enticed purple martins to nest by suspending hollowed-out gourds from their dwellings, and early European settlers adapted the custom. My grandfather followed suit. His purple martin community featured a church, a school, a post office, and various houses and shops, among them a tidy café/inn that I like to think of as Hal & Mal's. In the 1840s, when John James Audubon was trekking about the continent making his historic bird paintings, he recorded in one of his journals, "Almost every country tavern has a Martin box on the upper part of its signboard; and I have observed that the handsomer the box, the better does the inn generally prove to be."

We always eagerly awaited the spectacle of these winged visitors to Papa Stewart's yard. He taught us that the faithful martins are the only bird species that is totally dependent on human-supplied nest boxes and that they actually prefer to nest in close proximity to us. In return for the accommodations, they provided us with endless hours of song and graceful aerial acrobatics, and, as my grandmother liked to point out, they feasted on vast quantities of insects, especially the dreaded scourge of summers, the ubiquitous and insidious mosquito.

The Stewart girls did not ramble far from their roots in life or in death. They grew up in the Pine Hill area of Wiggins and in the sandy-soiled hamlet of Perk, just five miles south, barely beyond Red Creek, and all three are buried on a hillside in Woodlawn Park Cemetery, just east of Wiggins. The middle sister, Myrtis, was a ball of energy—a doer. She cooked, sewed, taught Sunday school, and served as our Cub Scout den mother.

Aunt Myrtis's gumbo

In the summer months, she delighted us by making popsicles from Kool-Aid and fruit juice. In addition to being a gracious and loving aunt, Myrtis Stewart Krohn was a devoted wife and mother. Her husband, L. A. Krohn, used to ask her to refill his empty drink glass by saying, "Sweeten her up, Myrtis." And to this day, we pay homage to that remarkable lady by using that phrase around my house

L.A. was the business manager at Perkinston Junior College and was always involved in something. He never had any trouble recruiting his kids, Larry, Genene, and Terry David (known as Tiger), as well as Hal and me to work on his projects: clearing land, building weekend cabins, digging lakes, organizing this or

that adventure. The best one was the houseboat and camp on Mary Walker Bayou, a brackish waterway connected to the magnificent Tchoutacabouffa River, which flows thirty miles south to a wide mouth just north of Biloxi Bay. Noted Mississippi potter George Ohr dug most of the clay for his exquisite and otherworldly masterpieces from the banks of the Tchoutacabouffa, which takes its name from the Biloxi Indian word for "broken pot." We also loved the local lore regarding how the bayou got its name. Mary Walker was supposedly a "lady" from New Orleans who came to live in a fishing and logging camp along the waterway but was subsequently extradited back to Louisiana to account for her alleged misdoings.

In addition to the old houseboat, which was rigged with a full kitchen for long weekends out on the river, Uncle L.A. and Aunt Myrtis's compound featured a waterfront pier with johnboats and ski boats. At this weekend and holiday paradise, my cousins, brother, and I were drawn to the "Big Oak," a massive live oak tree perched on the banks of the river where we tied up our watercrafts, set up day camps, and spent summer days skiing, fishing, swimming, and lazing around. Our friends the Cooks and the Davises also kept camps at Mary Walker. Billy and Mary Cook were like our family—we spent enormous amounts of time with them and their kids and accompanied them on many memorable summer sojourns to the Great Smoky Mountains and the emerald beaches of northwest Florida.

Mary Walker is also where Hal and I first tasted Aunt Myrtis's gumbo, which I now think of as fish-camp gumbo (meaning that it uses whatever has been caught that day) and which we serve today at Hal & Mal's. Aunt Myrtis caught and picked blue crabs, bought or netted local shrimp, made a magical dark roux of pork fat and flour, and then slowly added sausage, ham, okra, onions, tomatoes, peppers, a bay leaf or two, and a handful of herbs and spices. Hal and I always got tickled when customers called us to their table to complain about the leaf in their gumbo: "Yes, that's a bay leaf we use for seasoning, and it's a good luck charm for the patron who ends up with one in their bowl. Like the baby in the King Cake, the recipient gets to host the next party!"

On our first Hal & Mal's menu, I wrote that our Aunt Myrtis's gumbo recipe was created and learned at Mary Walker Bayou, near the hamlet of Vancleave. One day, Sissy Anderson, widow of well-known Ocean Springs painter Walter Anderson, lunched at the restaurant and summoned me to her table to set the record straight: Mary Walker Bayou is nearest to Gautier, which happens to be Miss Sissy's childhood home. I—and the menu—stand corrected. ∎

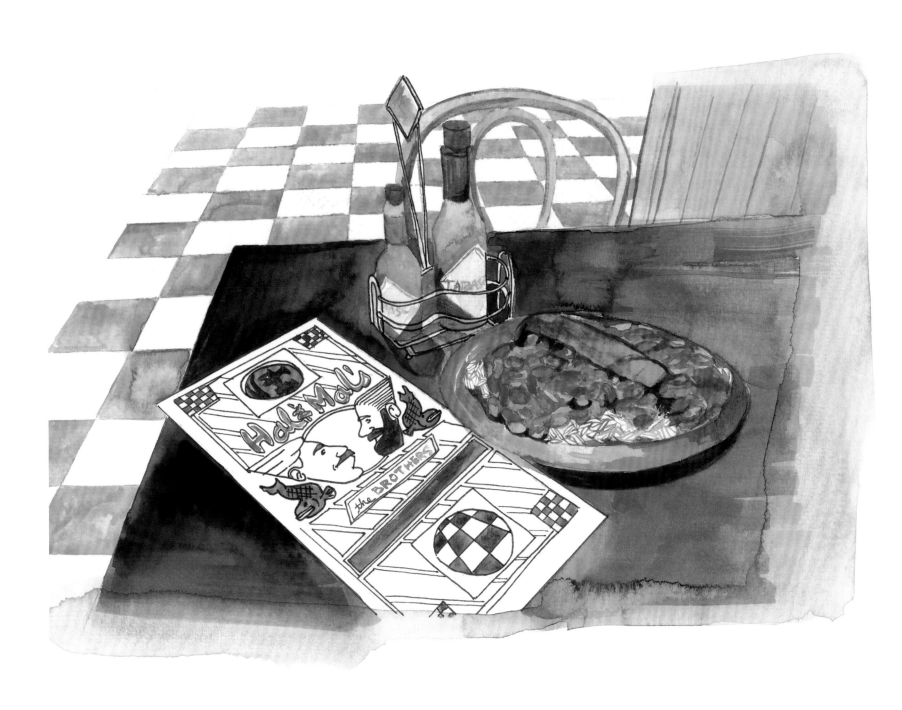

Red beans and rice and menu
designed by Zita Mallory Webb

RED BEANS & RICE

As kids, Hal and I were never served traditional New Orleans–style red beans and rice. We got plenty of hoppin' John and volumes of Grandmother Pat's version of large boxcar lima beans with chunks of ham, often served with rice, but we never got spicy, creamy kidney beans with sausage over rice. For that we had to wait until we moved to New Orleans and the Faubourg Marigny in 1975 to work at the Bourbon Orleans Hotel. As best I can recall, I first came face-to-fork with this quintessential staple of working-class New Orleans fare at Buster Holmes's Restaurant, a soul-food eatery at the corner of Burgundy Street and Orleans Avenue, just a couple of blocks from the Bourbon Orleans, that served good, cheap standards to locals and the occasional errant visitor. This dish was a Monday must—and often several other days a week as well. Buster's was tasty, comforting, and easy on the wallet. I had a Buster Holmes T-shirt that I wore for a decade until it finally unraveled, faded, and deteriorated to the point that I could no longer deny that it was a rag best suited for washing the car. Clarence

"Buster" Holmes was born near Point a la Hache in 1907 and moved to NOLA after the Great Mississippi Flood of 1927 to work as a dishwasher at the Monteleone Hotel. An order of his signature red beans apparently cost sixteen cents when he opened in 1960, and the price didn't go up much over the years. Hal and I loved Buster's fried garlic chicken, greens, ribs, and pork chops (all served with beans and rice). The doors to the front bar were usually open, allowing French Quarter street life to waft into Buster's while the smell of food and the sounds of the jukebox—an inspired hodgepodge of Miles Davis, Professor Longhair, Fats Domino, and James Booker—enticed passers-by off the street. The cigar-chomping King of Red Beans closed his restaurant in the early 1980s and died on a Monday in February 1994.

This introduction to red beans served us well, and we eventually developed our own recipe for what became our signature dish, featuring cured ham products, the vegetable holy trinity, a heaping cup of garlic, a cup and a half of chopped parsley, fifteen

bay leaves, cayenne, thyme, basil, and crushed red peppers. We learned how to cream the beans and precisely set everything to a slow boil in a big black pot.

When we opened Hal & Mal's, the first two pots on the stove held red beans and gumbo. It was what was important to us and what we thought we could do well and consistently. We were right. Thousands of pounds of beans and rice have emerged from the tacked-on, ramshackle structure we lovingly call our kitchen. Hal and I built it with the assistance of Robert Cochran, who was rehabbing a broken arm while supervising our handiwork, and our dear friends David Patterson, sculptor-turned-builder John Hamrick, and Larry Robinson. Anyone who passed by or dropped in to see what the crazy White brothers were up also risked being pressed into service. After many months and many, many cases of beer, we had cobbled together the pieces and got a permit. We have subsequently won several red beans and rice festival contests (with trophies to prove it), and the proceeds from our legumes have financed the college education of Hal's son, Taylor, and endowed a scholarship at Hinds Community College. Over the past thirty-two years, we have no doubt cooked and served enough twenty-five-pound bags of beans to fill Jackson's Memorial Stadium. ■

THE GENIUS OF SAMBO MOCKBEE

Born in Meridian and educated at Auburn University, architect Samuel "Sambo" Mockbee was a genius. He and his lovely wife, Jackie, settled in Canton, Mississippi, to raise their three daughters (aka the Mockettes) and their son, Julius. He first formed a partnership with his classmate and friend, Tommy Goodman, who now lives in Carrollton, before becoming a partner in Mockbee, Coker & Howorth with Tom Howorth, who now has a flourishing practice in his beloved Oxford.

Not all that long after I met Sambo in the early 1980s, he got the gig to design the Mississippi Pavilion at the 1984 World's Fair, and we had an all-night celebration at Hal & Mal's, with Sambo's friends and family gathering at his favorite corner table (which, now that I think about it, was his table before it became Willie Morris's). When the World's Fair was over, he gave us the model of the Mississippi Pavilion, and we mounted it in the foyer along with a magazine cover featuring Sambo and the model. During that era, many of our best friends would gather at his office on North Street in downtown Jackson every Friday for beer. Sambo always drank Heinekens straight from the bottle—and lots of them. So we all drank lots of Heinekens. In 1983, when I announced I was having a St. Paddy's Parade, he wrote me a three-hundred-dollar check from his company checkbook to buy a trailer for our very first float. (Jill Conner Browne and the Sweet Potato Queens still use that trailer today in the Fondren-based Zippity Doo Dah Parade.) Sambo also created and was the first Head Bucket of the Buckethead Judges, who preside over the parade and select the winners of the awards, which include the Sambo Mockbee Buckethead Award for excellence and creativity in design and implementation. And in 1991, when he left his downtown Jackson office to teach architecture at Auburn, we grieved and sent him off to Alabama with his briefcase full of big ideas.

Two years later, Sambo and a colleague, D. K. Ruth, founded the Rural Studio, a program that teaches students about architecture and social responsibility by designing and building homes for impoverished rural residents of Hale County, Alabama, only

eighty miles from his birthplace and more or less halfway between Meridian and his beloved Tigers (War Eagle!). These homes were often constructed using unusual materials—hay bales, rammed earth, telephone poles, old wine bottles, cardboard, tires and windshields—that might otherwise be considered waste. Sambo also created a dish at Hal & Mal's, the Gut Bomb, that involved three hot tamales doused with hot sauce and topped with Black Cat chili, cheddar cheese, chopped green onions, and jalapeños. The Bomb never won any awards or became part of the Auburn architecture curriculum, but members of the Hal & Mal's faithful still come in and order it. He was an eating man's architect and loved to sit before a plate of barbecue or soul food, especially at his favorite hometown eatery, Callie Wingate's (Wingate's BBQ). Sambo truly loved entertaining folks and took great pride in showing off local culture.

I remember once making the sojourn to visit Sambo at the Rural Studio. Raad and Karena Cawthon, Rickey Cleveland, and I loaded up and headed east to see what Sambo had built. When we arrived, Sambo insisted that we go to the Black Warrior River for an initiation; once there, he ordered us to strip and go for a swim. Karena politely declined, so there we were, four middle-aged Mississippi boys skinny-dipping in the river in broad daylight as if we were kids in the creek, wild and free, at least for the moment. That was what it was like with Mr. Mockbee. Everything was a ritual, a requirement of faith, a commitment to trust and the fellowship. He got people to commit, to strip naked and believe in his big ole ideas. I was all-in from the moment we met. ■

Model of World's Fair
Mississippi Pavilion

Sambo's "Gut Bomb" or tamale pie
for the more sophisticated consumer

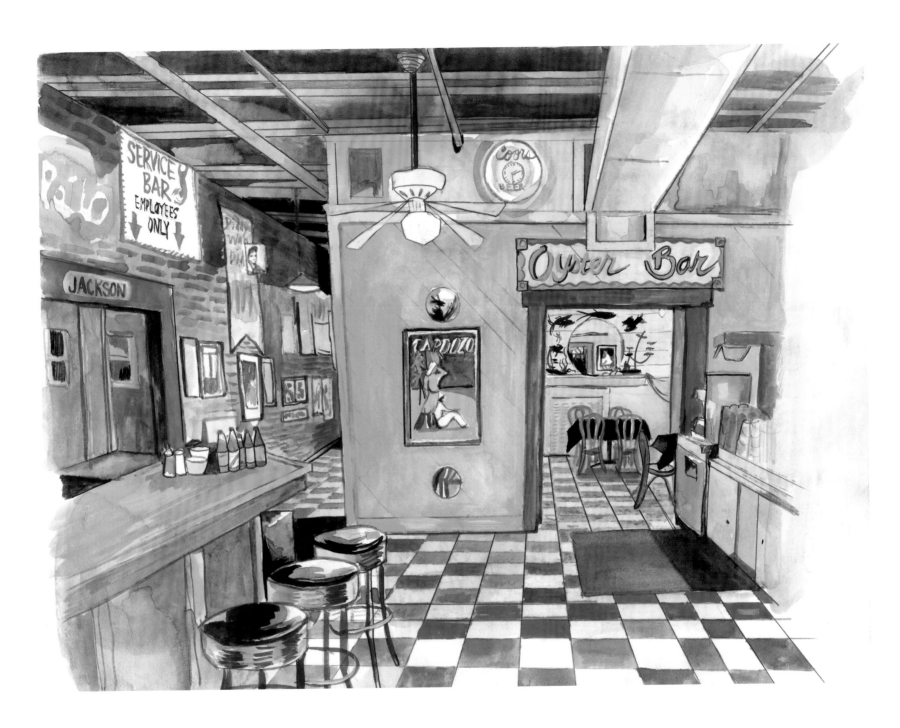

Interior view of the Oyster Bar
and hallway to courtyard

ROOMS WITH HOOKS AND HOLES

When we moved into the old GM&O Freight Depot, there were two adjacent rooms on the first floor, at the south end, that had dropped ceilings with vents, oval openings in the walls, and hundreds of large hooks overhead. We briefly wondered what the rooms were for and then made the one closest to our front door into the office. We unscrewed the scary-looking hooks but left the holes, added central heating and air-conditioning to the vent system, and didn't think much more about the weird design. In the corner, we installed an old TV that had been in our dad's office when he was president of Northeast Community College. Somehow, it still works. For a while, the second room housed the oyster bar, though we moved it out to the Patio Bar many years ago. Joey Mitchell and I built that oyster bar for Oliver's Boar's Head Pub back in 1979. Harrison "Little Baby" Welch was our shucker there, and he later came to Hal & Mal's. The room is now a dining room, though it's still known as the Oyster Bar.

In the early days, we used to entertain small children by encouraging them to crawl through the lower ventilation holes.

We also thought it was entertaining to jokingly require would-be employees to fit through the holes before being hired (probably not funny today, but back then, people smoked in public, drank at lunch, carried pagers, and talked on landlines and pay phones).

The Oyster Bar was where Mississippi musician and humorist Paul Ott introduced Hal to one of his heroes, Justin Wilson, who was known for Cajun cuisine, humor, and storytelling. Wilson was from Tangipahoa Parish, where our Aunt Voncile and Uncle Virgil Shiel lived most of their adult lives. Uncle Virgil lived very close to the land and in many ways embodied much of the same spirit and earthiness that animated Wilson's cooking and outdoor humor. Having Chef Wilson visit Hal & Mal's and eat with us was an honor and something that "I gar-on-tee!" (as Wilson would say) Hal never forgot.

Years after Hal & Mal's opened, a fellow came in for lunch who had worked in the building in its former life as the Merchants Company. He took us around and explained how the rooms had been set up and used. When we got back to the dining room

and he was paying Mama Zita for his lunch, he said, "Oh, by the way—those two rooms you are using for the office and the Oyster Bar? They were banana-ripening rooms. We got boxcars of green bananas in directly off the boats in Gulfport and hung them from the hooks that used to be in the ceiling. Then we pumped ethylene gas in through those vents and vented it out those holes in the wall to ripen the bananas." Ethylene gas, I subsequently learned, has long been used commercially to ripen tomatoes, bananas, pears, and a few other fruits. Mystery solved. ■

BROTHER WILL & THE VELVET ELVIS

Born in Amite County, Brother Will Davis Campbell grew up to be a Baptist preacher, activist, author, musician, and lecturer. His autobiographical *Brother to a Dragonfly* was a finalist for the 1978 National Book Award and was an immense help to me in putting my relationship with Hal in perspective. Brother Will loved Hal & Mal's and once brought Waylon Jennings and Jessi Colter in for dinner in the late 1990s. I got Waylon to sign our wall and my tattered baseball cap with his Flying W on it. "Where did you get this old thing?" he asked. "You gave it to me in 1974, when you were playing USM and staying at the Ramada Inn where I worked. We ran into each other at the newspaper dispenser early one morning, we talked a while, and you gave me the cap. Had it ever since." "Damn," he said, "that was a long time ago."

To his chagrin, Will inspired cartoonist Doug Marlette's *Kudzu* comic strip character Will B. Dunn. Doug once came to Hal & Mal's when he was in town on a book tour and taught an art class in the Oyster Bar for my daughter, Zita Mallory, and her classmates. Doug signed our autograph wall as well. A Pulitzer Prize–winning editorial cartoonist and novelist, Doug was born in North Carolina but lived for a time in Laurel, Mississippi, and died in a pickup truck crash in Marshall County. News of his death unnerved me, reminding me of the loss of a childhood friend, Little Polk Evans, in 1967. Little Polk was our neighbor growing up in Perkinston, and both Hal and I idolized him. I once literally walked in his fresh-turned footsteps as he plowed in his family's garden: I wanted to be like him when I grew up, and I thought that placing my feet where his had been would ensure that destiny.

Although the Campbell family church has Bibles emblazoned with the Ku Klux Klan symbol, Will's parents raised him to be culturally tolerant. Will was country liberal, or, as some like to say, he leaned like NASCAR—all left turns. His local Baptist congregation ordained him as a minister when he was seventeen, and he later held a pastorate in Louisiana from 1952 to 1954. At that point, he became director of religious life at the University

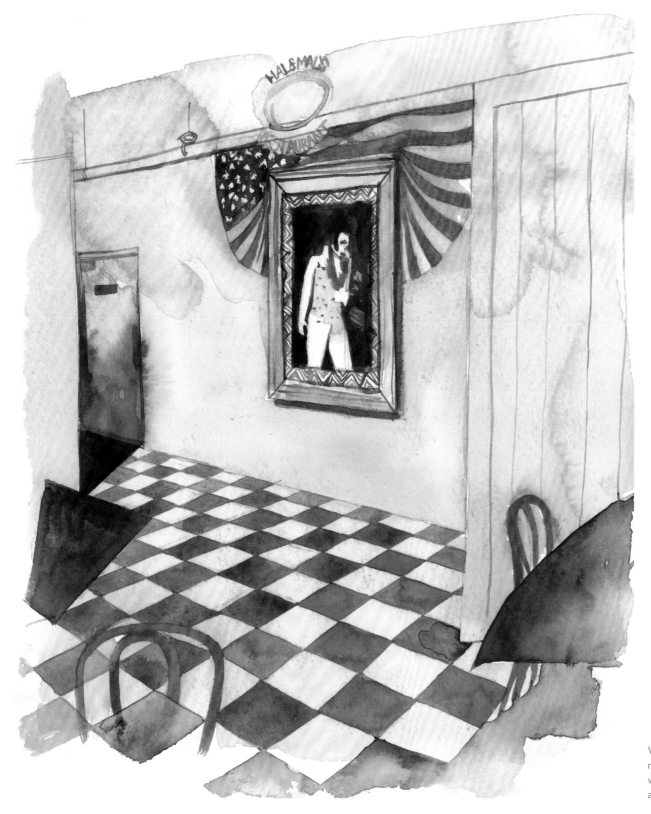

Velvet Elvis #1 in main dining room with American flag and Coors beer sign

of Mississippi, though he resigned just two years later, in part because of the hostility (including death threats) he received as a supporter of integration.

One evening, Willie Morris called and said that he and Will were coming over to Hal & Mal's with some French journalists: "They want to interview us, and I want a drink." The group showed up, and the film crew went about setting up their gear at Willie's table in the corner. When Willie moved from Oxford to Jackson in 1990, I installed a phone jack next to that table, and from that day forward, it became known as Willie's table. As the evenings wore on and he had questions or suggestions or observations he needed to share, he would sometimes start making calls to people whose numbers he had in his vast and star-studded Rolodex. He also liked to make prank calls to his friends. When cell phones came along, Willie always referred to them as "celluloid phones." Whatever anyone offered him—a book, a piece of furniture, or a painting—he would say, "Fax it to me" and then let out a boyish hoot. Perhaps Willie was ahead of his time and envisioned the 3-D printer.

When the French journalist and film crew were ready, Willie told Will to go first and had a glass of wine with me at the bar. Then they traded places, and Will waddled over to me and said,

"I've been in this joint hundreds of times, but for the life of me, I can't seem to remember where the head is." I pointed toward the neon restroom signs on each side of the giant movie poster display case salvaged from the old Lamar Theater in downtown Jackson. The Lamar Theater was built in 1947 on the site where One Jackson Place stands today; the theater closed in 1976 and was razed in 1982 by the Jackson Redevelopment Authority. The display case now holds the Velvet Elvis, a true cultural tapestry and collector's item (if you like folk highway art, that is). An American flag is draped over the top of the display, demonstrating our great pride in our country and offering a tribute to Elvis's patriotism. A veteran once took offense at this montage, berating me aggressively about the manner in which I presented the King, the flag, and my version of patriotism. In his view, bunting was appropriate for such a display, and the American flag should never be presented in this fashion—ever. I begged to differ. After being insulted and accused of being a Benedict Arnold, I politely asked the soldier to leave our humble place and take his opinion with him. As life often reminds us, one man's art is another man's anarchy.

"The men's room is to the left of Elvis," I said to Pastor Will. Already heading in that general direction, he turned back to me and retorted, "Most things are!" ■

In this grouping of trophies is the graduation picture of Connie "Bob" Vernon of the legendary Vernon Brothers band, one of the house bands of Hal & Mal's.

WILLIE'S BOWLING TROPHIES

There are two reasons we have bowling trophies in Hal & Mal's. One is because I'm a big fan of writer Richard Brautigan, whose first novel, *Trout Fishing in America*, ignited my reading of short fiction and finding a connection to stories about people I admired. Brautigan was published by Sam Lawrence, a titan of the mid-twentieth-century New York publishing world whose other authors included Kurt Vonnegut, Barry Hannah, Joseph Heller, Pablo Neruda, Miguel Ángel Asturias, Katherine Anne Porter, and William Saroyan. I devoured the rest of Brautigan's poems and fiction, including his 1975 novel, *Willard and His Bowling Trophies*, set in San Francisco in the early 1970s. The title character is a papier-mâché bird who shares the front room of a San Francisco apartment with a collection of bowling trophies stolen from the home of the Logan brothers three years earlier. The human tenants of the apartment are John and Pat, who've just returned from seeing a Greta Garbo movie at a local theater. Their neighbors, Bob and Constance, are a married couple whose relationship is on the

rocks, leaving Bob depressed. The Logan brothers have turned their passion for bowling into a vengeful quest to retrieve their trophies. Brautigan expertly constructs a series of comically sad intersections among these characters.

The other reason for my affinity for bowling trophies is Willie Morris. When Willie returned to Mississippi in 1980 to take a position as writer in residence at Ole Miss, he quickly scouted out establishments from which to hold court. Willie naturally first became attached to the Hoka, where Ronzo and Dees provided a bohemian outpost for those looking for café society and a late-night place for films, coffee, and conversation or to brown-bag an illegal bottle in the dark of an unknowing yet evolving Yoknapatawpha.

In addition to Taylor Grocery's catfish and Ruth & Jimmy's in Abbeville, Willie loved the old Sizzler Steak House out on Highway 7, east of Oxford, which allowed Willie to bring his writing students after hours and host guest lectures, with participants free to imbibe as long as they kept it quiet. On one such evening,

Willie did his usual grandiose introductions and then pulled one of his pranks, presenting his out-of-town guest with a trophy "from the university and the students" to express their gratitude that the guest had come to share knowledge and stories. Willie trotted out this one on multiple occasions: each time, the visitors, overcome with pride and emotion, would profusely thank Willie and the kids and return to their seats to admire the trophy, only to realize they had received a bowling trophy—perhaps from the Pontotoc Invitational or the New Albany Seniors' Tournament—taken from the wall of the Sizzler. So when Willie moved from Oxford to Jackson in 1990 and we wanted to make him feel at home at Hal & Mal's, we decorated the ledge around his favorite table with bowling trophies I'd found at a flea market. Willie was tickled to no end.

In 1990, Sam Lawrence bought a grand house on Oxford's Old Taylor Road, just a stone's throw from Faulkner's Rowan Oak. Two years later, Lawrence donated items related to his publishing career—books, manuscripts, photographs, and literary memorabilia—to the University of Mississippi, and in April 1993, the university opened the Seymour Lawrence Room in the Department of Archives and Special Collections.

So, in a perfect poetic ending, the manuscript for *Willard and His Bowling Trophies* would now rest somewhere in the 108 boxes in the Lawrence Collection at the J. D. Williams Library, just a few Mississippi miles from the old Sizzler. Alas, those parts of the Lawrence legacy are not there. But in the spirit of Willie Morris's pranks, the bowling trophies rest along the wall by Willie's favorite table at Hal & Mal's to honor both Willie and Richard Brautigan and their shared devotion to creative writing, love of life, and sense of humor. ■

ALBERT KING & THE AUTOGRAPH WALL

The first time I ever laid eyes on Albert King, he was sitting behind the wheel of his bus, which was parked in front of Geno's Blues Club off Bailey Avenue near the Jackson Mall. He was on break from a show he was performing at Geno's and smoking his signature pipe. We arrived with our hipster entourage straight from a book signing at Lemuria Bookstore for Barry Hannah's *The Tennis Handsome*, a novel that manages to be both raucous and tame by Barry's standards. It was 1983. I had arranged a keg of Stroh's Beer from cousin Dink Drennan for the literary occasion, and after we drained that, we all went to hear King. Back then, Lemuria was in Highland Village, as was Lynn Clark's bookstore, the Bookworm; the "Bold New City," as Mayor Dale Danks liked to call Jackson, had a serious literary presence. Barry had shown up wearing a wildly politically inappropriate CSA cap and had a pretty good buzz on, not just from the beer but also from his new novel and from having just won a Guggenheim Fellowship.

Geno, an ex-cop from Chicago and an old friend of King's, was ill prepared for the crowd that night and ran out of beer early, leaving us to choke down Champale for the rest of our long evening of debauchery. We had to keep an eye on Barry all night, as the dynamic of the juke joint in south Jackson and his head-gear made for interesting conversation and energy. Barry was in his element, and once King took the stage, Hannah hit the dance floor, dancing with everyone's wives and girlfriends. Barry liked to portray himself as a ladies' man, and he once proclaimed to a group of late-night cohorts at the Hoka in Oxford that he "shed wives like Hemingway." Of course, this was all boozed-up late-night theatrics: Barry was very much Susan's man, and we all knew it.

Albert King is credited with two firsts at Hal & Mal's. In 1985, he was the first act we officially presented under the banner of Hal & Mal's (though our name is misprinted on the poster as *Hai Mai*). And he was also the first person to sign the Autograph Wall.

Albert King was born Albert Nelson on a cotton plantation near Indianola on April 25, 1923, making him a Taurus, which may or may not be a bad sign to be born under, though his biggest hit was indeed "Born under a Bad Sign." The song's lyrics were written by Stax Records' rhythm and blues singer William Bell, with music by Stax bandleader Booker T. Jones (of Booker T. & the MGs). Recalled Bell, "We needed a blues song for Albert King; I had this idea in the back of my mind that I was gonna do myself. Astrology and all that stuff was pretty big then. I got this idea that might work."

King's smooth singing and large size earned him the nickname the Velvet Bulldozer. Before the 1985 concert, which I coproduced with Charles Evers, King was sitting in the office at Hal & Mal's tuning his guitar. A friend of mine, photographer Hubert Worley, walked in and started snapping photos of King. He stopped, cleared his throat, and politely asked, "Excuse me, sir, but what is your intention with those photographs you are taking of me?" Hubert said he was just documenting his performance and didn't have a specific purpose or use for the photographs. Albert said, "Well, then, you might want to ask my permission to photograph me, out of politeness." Hubert apologized, asked permission, and was rewarded with, "Yes, you may, and thank you for asking." After the performance, I got the idea to ask King to sign his name on the wall in the dining room that had previously housed an old gas heater. The heat had stained the brick over the years, and at some point it was painted over, creating the perfect surface for something special. He wrote, "Albert King, love you." We have been fortunate enough to add many more names to our Autograph Wall in the three decades since, and I certainly can't claim, as King did, that if it weren't for bad luck, I wouldn't have no luck at all. ∎

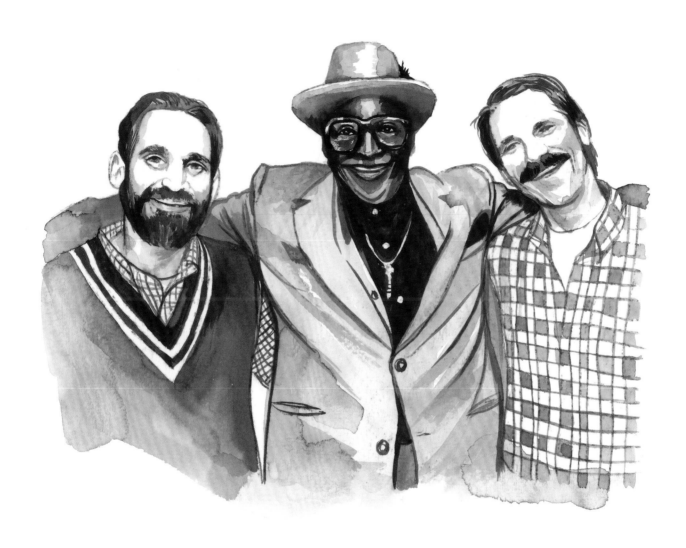

Mal, Albert King, and Hal, 1985

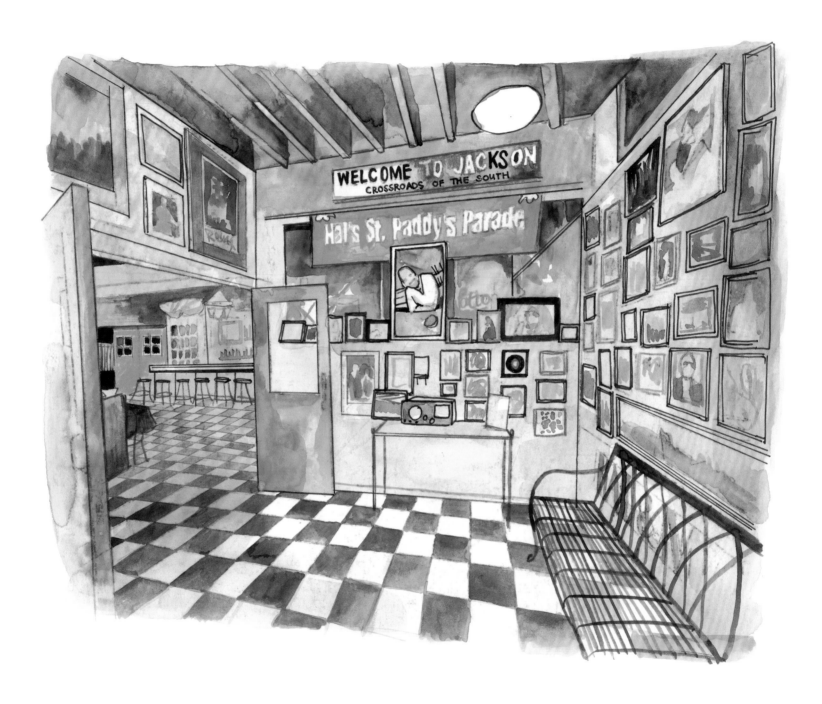

Interior foyer and old "Crossroads of the South" sign and St. Paddy's Parade banner

WILLIE DIXON

I've had the remarkable opportunity to work with Willie Dixon, Bo Diddley, and Leon Redbone but never Blind Blake. All these innovative artists have had a hand in the shaping of the musical mythology of "Diddy Wah Diddy" (1956), which was Bo Diddley's fourth single on Checker Records and the title of which Paul Canzoneri (aka Dick Smobey) and I borrowed for our publication and our radio show.

Bo Diddley recorded "Diddy Wah Diddy" on November 10, 1955, in Chicago, with himself and Jody Williams on guitar, Willie Dixon (who coauthored the song with Diddley) on bass, Clifton James on drums, Jerome Green playing the maracas, and Little Willie Smith on harmonica. At the time, I was oblivious—four years old and living in Perkinston, where my tastes ran more toward Mother Goose than toward Chicago blues.

In the early twentieth century, African Americans in the South frequently constructed mythical places, of which Diddy Wah Diddy was the largest and best known. There, according to legend, food abounded, residents did not have to work, and people and animals lived a carefree life. The song takes the perspective of a man whose lover lives in Diddy Wah Diddy, a locale "way off somewhere" that "ain't no town, and it ain't no city." Paul and I connected this line with our concept of Jackson and used it for our endeavors.

Not surprisingly, Bo Diddley's song is often confused with Blind Blake's 1928 song, "Diddie Wa Diddie," which has also been covered (with various spellings of the title) by numerous bands and artists, including Leon Redbone, who included it on 1977's *Double Time* as "Diddy Wa Diddie." Blind Blake's song features the line, "I wish somebody'd tell me what diddy wah diddy means."

Willie Dixon was born in Vicksburg in 1915 and left Mississippi in 1936 for Chicago, where he initially became a boxer, winning the Illinois Golden Gloves Heavyweight Championship (Novice Division) in 1937. At six and half feet tall and weighing more than 250 pounds, he fought professionally and briefly served as Joe Louis's sparring partner before a dispute with his manager over money led Dixon to hang up his gloves. While at

the gym, Dixon had met Leonard "Baby Doo" Caston. Two years younger than Dixon, Caston was also a Mississippi native who migrated to Chicago in the mid-1930s. He eventually persuaded Dixon to pursue music seriously, building his first bass using a tin can and one string. Both men went on to become blues icons—Caston as a pianist and guitarist best known for "Blues at Midnight" and "I'm Gonna Walk Your Log," Dixon as an innovative songwriter whose works had tremendous influence on and were frequently covered by rock 'n' roll bands such as the Doors ("Back Door Man"), Led Zeppelin ("Bring It on Home," "I Can't Quit You Baby," "Whole Lotta Love"), Eric Clapton ("Hoochie Coochie Man"), the Rolling Stones ("I Just Want to Make Love to You," "Little Red Rooster," "You Can't Judge a Book by the Cover"), the Grateful Dead ("Wang Dang Doodle"), and many, many others. From the 1970s until his death in 1992, Dixon also played a major role in fighting to obtain proper credit and royalties for his work and that of other blues musicians.

Willie Dixon came home to Mississippi in 1990 to be received by Governor Ray Mabus and to promote his book, *I Am the Blues.* Chrissy Wilson and the staff of the Mississippi Department of Archives and History organized a panel discussion in the historic House Chambers of the Old Capitol in conjunction with the project All Shook Up: Mississippi Roots of American Popular Music. I was honored to introduce the program, which included ethnomusicologist and Mississippi Blues Trail scholar Jim O'Neal interviewing Dixon. In addition, John Evans and the crew at Lemuria Bookstore hosted a book signing for Dixon. When I think back to all the major writers and musicians who have come through the doors of Hal & Mal's as a direct result of John's efforts, I am both amazed and humbled. Lemuria has been incredibly important to the culture of our "ain't no town, ain't no city" Jackson, just as Square Books has been in Oxford. So many successful and creative American communities have a first-rate bookstore at their core, even in an age when people buy fewer and fewer physical books. I know Jackson's dot on the map would be much smaller and less artful without Lemuria.

While Willie Dixon was in Jackson, we interviewed him for the *Diddy Wah Diddy.* When we asked how he felt about the fact that we had usurped his song title for our publishing brand, he just chuckled and said, "Oh man, it ain't nothing but a thing."

I still wish somebody'd tell me what diddy wah diddy means. ∎

GRISHAM-MORRIS LATE-NIGHT CLOSING

Hal & Mal's has hosted many book events and momentous literary occasions. One of the earliest was the organizational party for the BookFriends of the University Press of Mississippi, which featured the music of the incomparable Mose Allison as well as a reading by Oxford's Barry Hannah. We were also the site of parties for Eudora Welty's ninetieth birthday and Willie Morris's sixtieth. Our release party for the voluminous *Encyclopedia of Southern Culture* featured readings by Charles Reagan Wilson and performances by Jack Owens and Big Jack "Oil Man" Johnson. Big Jack was born in the delta town of Lambert in 1940, one of eighteen children of sharecropper parents. Jack got his musical start at his father's knee and picked up the electric guitar as a teenager, attracted to the urban sound of masters such as B. B. King. He left the cotton fields and became a truck driver for Shell Oil, leading to his nickname, but continued to play country and blues fiddle and mandolin at local venues.

Probably the most unnoticed but culturally famous event to take place at Hal & Mal's was John Grisham's very first book signing for *A Time to Kill*. At the time, Grisham was a state legislator who was looking for an opportunity to sell a few copies of his first book. I don't know who he approached before we got involved, but I doubt we were his first choice. My friend Lynn Clark, the owner of the Bookworm in Highland Village, asked if we could help out— he was looking for somewhere to gather with a few friends. Lynn's pitch was that although only his friends and a handful of legislators would buy the book, we would "probably sell a few drinks." So I agreed.

The event came and went without much fanfare, and as best I can recall, Lynn was right—not too many folks showed up. I was busy and didn't even bother to get a copy of the book. Years later, after he had become John Grisham, Bestselling Author, he gave me a signed copy of the book. John has written Hal & Mal's into some of his other books, and in 2015, he organized and we hosted the Willie Morris Luncheon at the inaugural Mississippi Book Festival. I was unable to attend the event, but according to those who did, John shared a few stories about his friend and

talked about how Willie encouraged him to write. In my role as executive director of the Mississippi Arts Commission, I had the honor of helping to present John with the 2009 Governor's Arts Award in Literature.

When Willie moved to Jackson in 1990, we set him up with his own table in the restaurant, where he received his guests and entertained his wide circle of friends and total strangers. A decade earlier, Sambo Mockbee had held court at this table. In those days, everyone who came to Jackson came to Hal & Mal's, and most of the time, Sambo or Willie was in the house. On one such evening, Grisham joined Willie at his table, and the two men sat there telling stories late into the night. At closing time, I cleaned up, put everything away, and locked up, but they were still not ready for their night to end. I joined them for a nightcap, but I'd had a long day and was ready to go home. So I tossed my keys into the center of the table and asked Willie to make sure to lock the place up when they left. After that, I just gave him a key. ■

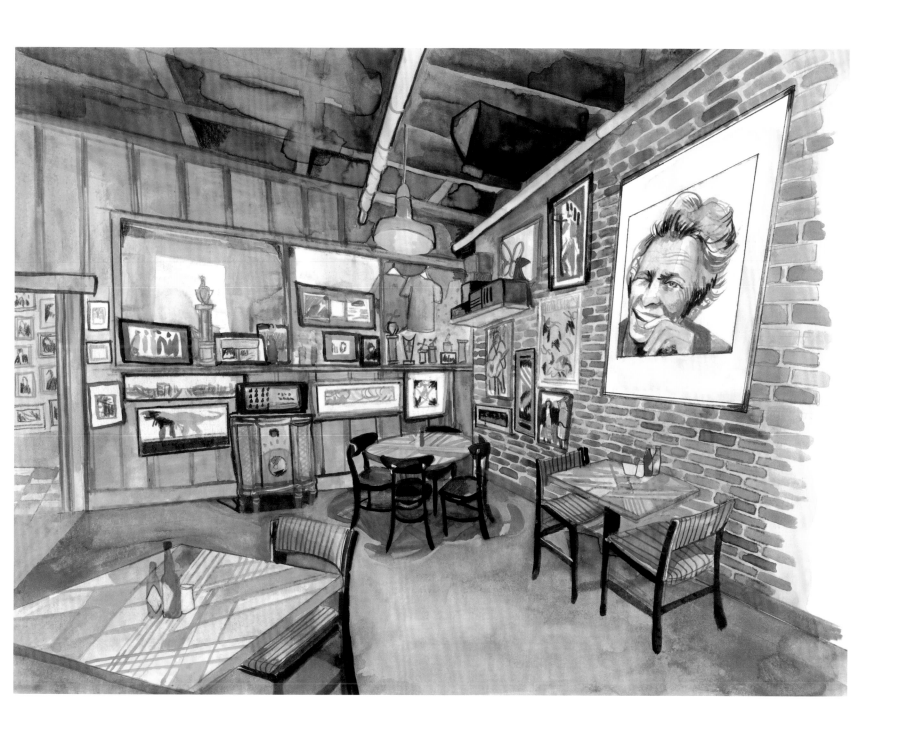

Willie and Sambo's family table with Steve
McQueen poster from the movie *The
Reivers*, based on William Faulkner's novel

Barry Hannah, Richard Ford, Mal,
and Willie Morris at the reopening
of Square Books, Oxford

LARRY BROWN & THE LITERARY STAMPEDE

I loved Larry Brown. We were the same age and had a barroom of friends in common. We became buddies when he learned that I used to coon hunt as a youngster in Stone County before moving to the hills. From that moment forward, no matter whether we were hanging out at Hal & Mal's or hobnobbing at the Governor's Mansion for a cocktail supper, Larry would grin and say, "There's my old coon huntin' buddy." Coon hunting, made famous by one of Mississippi's greatest humorists, Jerry Clower of Liberty (and later Yazoo City), was a dog sport: you let your dogs out and then built a fire. Once the dogs "got on a coon" and started barking, you took off in your truck, following the barking dogs. The barking was like an opera—each dog had a unique solo voice the owner could recognize: "Listen to old Blue. He's a damn fine hound. I believe he's taking that coon to the river bottom." Finally, the dogs would tree the raccoon, and after driving all over the county and up and down logging roads, the humans would take to the woods on foot to find the stupid dogs and coon. Having done so, the humans would shake the coon out of the tree, and the chase would start over. This went on all night. When everyone was tired of this charade and the adults were all liquored up, everyone went home and went to sleep. The youngsters, me included, would rise at daylight and go looking for the dogs. Our job was to bring them all home—beaten, bloodied, coon-chewed, and exhausted. After washing them, feeding them, and doctoring their wounds, we got to go back to bed. That was coon hunting. If you ever want to hear coon hunting told right, put on one of Jerry Clower's records; if you don't know what a record is, Google it.

Long before the ball got rolling for the Mississippi Book Festival, we attempted to add a literary component to Jubilee! JAM, a mostly music festival in downtown Jackson that took place during much of the 1980s and 1990s. Larry was an accomplished musician and songwriter and would get up on stage from time to time to jam with the Tangents or his other buddies. I once saw him perform with Alejandro Escovedo, a Texas-based based alt-country singer.

One year, we booked Larry to speak and share a reading at what we called a JAM Literary Luncheon, which predictably attracted mostly older, affluent ladies. My cantankerous brother, Hal, who felt he had better things to do, prepared a shrimp, chicken, and tuna salad plate for the guests and we set the room up nice, with tablecloths and flowers and such. After the salads were served, Larry was introduced and said a few words about his first career as a fireman and his current writing career. Then he announced he would read a short piece from his latest book of stories, *Big Bad Love*. He then began to read "Waiting for the Ladies." I have no idea why he chose that story—perhaps because the audience was mostly dressed-up country-club-type women. He read the first sentence: "My wife came home from the Dumpsters, said there was some pervert over there jerking down his pants and showing his schlong." He cleared his throat and read on. By the time he got to the second paragraph ("I slammed my beer down. I'd already slammed several down"), several of the women were looking around for the exit. As he read the next two sentences ("I said, by God I'd go take care of the son of a bitch. I said it ain't safe for women and kids to walk the roads, what'll you think'll happen when lawlessness takes over, and crime sets in, and the sick and sexually deviated can sling their penises out in front of what might be some little kid next time?"), a table of four quietly slipped out the door, followed by an older couple looking downward and shaking their heads. As Larry continued, audience members kept filing out. Larry's writing is known for its gritty realism, and some critics have called it brutal. His response? "Well that's fine. It's ok if you call it brutal, but just admit by God that it's honest."

Larry eventually wrapped up the reading, removed his glasses, and thanked the few hardy souls still scattered around the room. They clapped politely, and two or three ladies even came over to talk to him. When I went over and thanked him for coming, he chuckled, "Maybe I should have read something else. Sorry 'bout that." ∎

THE MOST-TALKED-ABOUT PLACE IN JACKSON

As I recall, LeFleur's Restaurant at the Jacksonian Highway Hotel on Highway 51 North (now I-55 North) promoted itself as the Most-Talked-About Place in Town. In its day, the Jacksonian was truly a state-of-the-art hospitality establishment, and the guest book reflected as much: Elvis and the Colonel, Bob Hope, Cher and Gregg Allman, and even Roy Rogers and Trigger (though those two presumably did not share a table and enjoy oysters on the half shell). The Jacksonian was constructed in the mid-1950s and was designed by a noted Jackson architectural firm, N. W. Overstreet. The ninety-room hotel and restaurant cost seven hundred thousand dollars to build in the mid-1950s, a considerable sum at the time. (Dumas Milner paid one million dollars to renovate the four-hundred-room King Edward at around the same time.)

LeFleur's, which specialized in Creole cuisine such as trout meunière, spoon bread, and West Indies salad, had previously operated in the basement of the Elks Building (now home to Underground 119); its new north Jackson location made it the place to see and be seen. The hotel and restaurant opened to a packed house on August 5, 1956, and the establishment was soon accepted into the prestigious Master Hosts organization, where it joined the Broadwater and the Longfellow House on the Mississippi Gulf Coast as well as the Bentley in Alexandria, where Hal worked after graduating from Northeast Mississippi Junior College in 1974. LeFleur's served its last meal and the Jacksonian closed its doors in late 1984, just as we were opening Hal & Mal's.

In 1979, when I put an oyster bar in Oliver's Restaurant in Jackson's Highland Village, I hired Harrison "Little Baby" Welch, who had shucked oysters for LeFleur's for many years. Oliver's was a high-end, white-tablecloth eatery with a French maître d' named Jacques who lived in a trailer on a lake off County Line Road at what is now the site of Barksdale world headquarters. I loved Jacques, but he complained often about Oliver's wine selection and repeatedly announced that our very best champagne tasted like "donkey pee-pee." To change the tired ambience, I not only installed the oyster bar in the Boar's Head Pub but also

Motorcycle urinals in men's restroom.
Wall painting by Harwell-Chudy.

Snoop Dogg

recruited Fingers Taylor to jam with Fred Knoblock on the stage heretofore reserved exclusively for piano players doing covers. Enigmatic singer-songwriter Mark Gray was one of the mainstays at the piano, though I did sneak in Tommy Tate from time to time to liven up the place. We ran an ad in the *Clarion-Ledger* with a picture of Little Baby to promote our new culinary offering. The ad cracked up my oldest and dearest Booneville High School buddy, Michael Rubenstein: "Brother, when I saw that picture of Harrison in the paper, I knew the vibe at Oliver's had certainly shifted."

In 2014, Pulitzer Prize–winning writer Beth Henley, a Jackson native, wrote *The Jacksonian*, a play set in 1964 in which respectable dentist Bill Perch is kicked out of his house by his wife and moves into the seedy Jacksonian Motel, beginning a downward spiral that ultimately leads to murder. On one epic evening, Beth stopped in to Hal & Mal's, joining a movable feast that also included Willie Morris, Barry Hannah, and Bill Dunlap.

And on the wall of the restaurant's dining room hangs one of my favorite photos, Kay Holloway's black-and-white image of Beth and Miss Welty; nearby, their signatures are among the many on our Autograph Wall.

For a couple of years, Fred Zollo, producer of both *Mississippi Burning* (1988) and *Ghosts of Mississippi* (1996), was a regular at Hal & Mal's, and we entertained the cast and crew of both films. *Mississippi Burning* is a fictionalized version of the FBI's investigation into the 1964 kidnapping and murder of civil rights workers James Chaney, Andrew Goodman, and Michael Schwerner in Neshoba County. *Ghosts of Mississippi* was based on the 1994 trial in which Byron De La Beckwith was convicted of the 1963 assassination of Medgar Evers. With the support of other state leaders, Ward Emling, Nina Parikh, and Betty Black at the Mississippi Film Office have attracted filmmakers by creating a good incentive program and a conducive environment for the industry, and although Willie Morris referred to the state

during these times as "overrun with movie people, all talking to each other on their celluloid phones," their presence was exciting and good for business.

The movie adaptation of our own John Grisham's 1989 novel, *A Time to Kill*, also brought Tinseltown to our neck of the woods. The 1996 film featured some serious Hollywood A-listers— Sandra Bullock, Samuel L. Jackson, Matthew McConaughey, Kevin Spacey, among others—and Jackson was abuzz with sightings of stars.

Michigan poet, novelist, and gourmand Jim Harrison frequently came to Lemuria Bookstore, and his March 1991 "The Raw and the Cooked" column for *Esquire* described a recent visit to our town: "A peculiar high point in Jackson, Mississippi, oddly a wonderful place. Actually drove from the airport through a tornado in an open BMW convertible. Very wet. After my pas de deux, went to Hal & Mal's for dinner, also to Willie Morris's wedding reception." Willie had married a longtime friend, JoAnne Prichard, and the hundreds of celebrants who descended from across the land included William and Rose Styron, George Plimpton, and David Halberstam, while the Tangents played "Darkness on the Delta."

We have hosted thousands of great artists and presented many memorable concerts, but I get asked about Snoop Dogg more than almost anyone else. Calvin Broadus Jr. was born in 1971 in Long Beach, California, but his father, Vernell Vardado, is from Magnolia, and his mother was born Beverly Tate in McComb. When the D–O–Double G visits his people in southwest Mississippi, he delights us by dropping in at Hal & Mal's, thrilling the sellout crowds and causing the stay-at-homes to marvel that he is playing our place.

In 1995, I scored the driftwood *Restaurant* sign that hangs over the main door as you come inside Hal & Mal's. I found the old sign in some debris along the Mississippi River levee in Algiers, Louisiana (across from the Quarter), and dragged that thing onto the ferry, all the way back to my apartment, and eventually to Jackson.

I have a photo somewhere of Charles Evers, Tyrone Davis, and Alan Parker taken in the Back Room when Parker was in town directing *Mississippi Burning* and Charles was promoting a show with Tyrone at Hal & Mal's. In addition to that film, for which he received his second Academy Award nomination as Best Director, Parker directed *Midnight Express* (1978, the first film for which he earned the Best Director nod), *Fame* (1980), *Pink Floyd—The Wall* (1982), *The Commitments* (1991), *Evita* (1996), and *Angela's Ashes* (1999). We hosted the wrap party when *Mississippi Burning* finished filming.

Years later, Vivian and I were walking down the street en route to dinner at Les Deux Magots in Paris and bumped into Alan, who stopped and chatted with us. As we were saying our good-byes, Alan asked, "Hey, can you get me a copy of that photo with Charles Evers and Tyrone Davis we took while we were filming *Burning*? I was just telling someone the other day about that night at Hal & Mal's, and I don't think they believed me." ∎

THESE GHOSTS ARE REAL

King's Tavern in Natchez, probably the oldest public gathering place in Mississippi, has made a tourism strategy of the paranormal goings-on in that historic building. We have taken a much lower-profile approach to ghost stories at Hal & Mal's.

In the three-plus decades that we have inhabited this old warehouse, we have heard lots of strange footsteps and eerie sounds. Hal was much more of a believer in ghosts than I am. He loved to tell spooky tales about being in the building alone and seeing lights come on and go off, hearing someone upstairs but going up and finding no one. He always claimed that things were being moved in the office, especially on his desk. (My desk is so cluttered and disorganized, I would never notice if something got moved.) Empty fruit and vegetable cans drop from the second-floor ceiling joists when the wind blows. Most likely, these were left behind by hungry workers with didn't have time for a lunch break and instead pilfered canned goods from the Merchants Company's vast inventory. Or the falling cans could be the result of ghosts expressing their displeasure about something. You never know.

Although I am somewhat skeptical about poltergeists, the building definitely is home to ghosts of history. Elvis supposedly picked up and dropped off cargo during his days as a truck driver, a possibility we honor by celebrating our opening anniversary on his birthday, January 8, which we used to call Elvismas. When the sun sets just right, the oversized mirrored disco ball that once hung in the old Lamar Theater appears to light up. To mark the new year, we drop a mammoth catfish, built by O. C. McDavid, from forty stories above Commerce Street. And every December 31, the fish-ghost reappears.

And as hard as it may be to believe, when we got this building in 1983, under a set of ancient wooden steps was a door marked *Colored* that led to a (nonfunctioning) toilet. The door is now in the permanent collection of the state-sponsored Mississippi Civil Rights Museum, just a block north of us. These unfortunate symbols are the real ghosts of Mississippi, and the injustices they

represent must not be forgotten as we look hopefully toward a future of reconciliation, equality, fairness, and love.

One of my favorite reminders of our building's history are the hundreds of Roman numerals marked on the brick walls. My theory is that warehousemen kept track of their cargo and hours worked with this informal accounting system. Many of the marks are accompanied by a workman's signature and/or some sort of code or symbol that could only be understood by the other laborers, much in the way that blues music contained hidden messages unintelligible to those outside the African American community.

Mississippi participated in the January 1, 1990, Tournament of Roses Parade in Pasadena, California. Headed by Pat Frascogna, the Mississippi Tournament of Roses Association devised a float that featured enormous replicas of the heads of four Mississippi natives, Leontyne Price, Tammy Wynette, Willie Dixon, and Elvis, rotating on records. The folks at Graceland initially vetoed the idea of Elvis but ultimately gave in after a public outcry, led by the Dawnbusters at WTYX, Bill Ellison and Scott Mateer. Ellison and Mateer were invited to ride on the float in the parade along with Tammy Wynette and Willie Dixon. After the parade ended, two Los Angeles deejays who had a feud with Graceland loaded the fourteen-hundred-pound head of Elvis—made of scrap metal, birdseed, flowers, and plants—onto the back of a truck and drove it cross-country to Memphis, broadcasting and making jokes along the way. The official keepers of Elvis's flame were not amused, and the head eventually made its way to Jackson—and to us. We have photos of it when it first arrived here, with birds feeding on the seed. The head ultimately was re-returned to a pop-art museum in California, but we kept Elvis's sunglasses, and they sit today where the steps used to lead to the upstairs.

And now, our old warehouse is home to the ghost of Hal, the true believer in spirits who will remain ever-present in this place. Hal, Brad, and I once took a trip to New Orleans, and before we could eat at the city's second-oldest restaurant, Tujague's, Hal insisted that we visit the tomb of voodoo queen Marie Laveau at the St. Louis Cemetery. As we walked through the cemetery, Hal turned to walk away, and I snapped a photo of him that is blurred and phantasmal. Yes, Hal believed in ghosts. ■

Elvis head from Rose Parade

Banner in courtyard
hallway from *Diddy Wah
Diddy* publishing days

DIDDY WAH DIDDY

I went online the other day and searched for *Diddy Wah Diddy*. I found a CD, *Diddy Wah Diddy . . . Ain't a Town, Ain't a City (Rock 'n' Roll and Hot Country from Jackson, Mississippi)*. I had never heard of it and was intrigued, so I ordered it. It features thirty unissued recordings made by producer Jimmie Ammons at his Delta Recording Studio between 1957 and 1964. My search also turned up a 1990 interview with Jim Harrison that appeared in our publication in 1990 and was reprinted in a book with permission from Aloysius Sisyphus and Malcolm White. There was a Yelp listing that said we were closed, and a few other references here and there, including one that mentioned us a resource and stated that we existed from 1985 to 1992. The address on Yelp was correct—the publication was domiciled at 200 South Commerce, same as Hal & Mal's. The *Diddy Wah Diddy* banner in the hallway between the courtyard (patio) and the main dining room was created by Ed Millet and once hung from the rafters of a cabin Sambo Mockbee and I rented for the Neshoba County

Fair. He hung a Canton flag on one side, and I flew the *Diddy* from the other. I remember walking with Hal from the house to the square, where we met our dad for a day of political speeches. Halfway back to the cabin, we ran into friends Ron Shapiro and Jim Dees, who had just come from the cabin and warned that if our dad was headed that way, he should be aware of the "rough air" they left hanging in the cabin.

Paul Canzoneri was my partner in crime at *Diddy Wah Diddy* world headquarters. At one time, we had both the monthly entertainment rag and a weekly radio show, the *Diddy Wah Diddy Radio Hour*, which ran on various FM rock stations in Jackson. There are bootleg tapes out there, and Duff Dorrough, late of Mississippi's house band, the Tangents, was one of our biggest fans and a collector of the recordings. Paul was a true ethnomusicologist and an accomplished collector of American music and history. His day job was running a graphic design and T-shirt enterprise in various low-rent locations around downtown. We

were urban revivalists and cultural proselytes going back to the early 1980s, true cultural soul mates. We worked together on the *Diddy* and many other projects, including Wellsfest.

Many contributed to the rise and fall of the *Diddy Wah Diddy*—Jill Conner Browne (aka Betty Fulton), David Adcock, Whit McKinley, Eyd Kazeri, James Patterson, Sam Prestridge, S. X. Ramone, Rev. Laszlo Weezilhed, Mike McCall, Dead Broke Jr., Mississippi Slim, and various other known and unknown voices looking to be published. But I relied then and still rely on the steady and artful hands of Hilda and Hap Owen and the wacky and wonderful Communication Arts Company to keep me headed in the right direction and out of the ditch. Jeanne B. Luckett also helped out with many of my knuckleheaded notions and certainly on the *Diddy.*

I stumbled into a short stack of *Diddys* the other day in the attic. As I thumbed through the accounts of life in the 1980s in Jackson, I discovered an ad announcing that Craig Claiborne would be signing *Southern Cooking* at Lemuria on Monday, October 12, 1987.

When I think back, I was involved in a dizzying array of activities in 1987: the publishing operation, Hal & Mal's, Jubilee! JAM, Zoo Blues, Wellsfest, Christmas by the River, and the St. Paddy's Parade. It was also the year that Vivian and I bought our first house on Council Circle (before the term *Fondren* was the hipster-descriptor for the neighborhood) and that our daughter, Zita Mallory, was born. We were a busy bunch.

I also found a 1986 *Clarion-Ledger* article about me written by my good buddy Mike McCall, who at the time was the paper's business editor. As I reread the piece, I was amazed not only by all the things in which I was engaged but also by the fact that I apparently did not mention Hal & Mal's. Thinking back, I probably left it out because the Lamar was using the space at the time and I wasn't very excited about that operation, or maybe I was withholding details about this really big idea. In any case, the story provided an informative snapshot of my previous business dealings.

I have a copy of the June 9, 1986, issue of *Time* bearing an address label indicating that the subscriber was O. C. McDavid at 1612 St. Ann Street in Belhaven. O.C. was a newspaper man, a visual artist, and a great friend who at one point had a studio on the second floor above Hal & Mal's and served as grand marshal of the St. Paddy's Parade. O.C. and Willie Morris served as the *Diddy*'s spiritual advisers and editors emeritus. O.C. came into the restaurant one day in June 1986 and asked if I'd seen the latest *Time* magazine, which I had not. I had taken a bunch of people on a tour of the Delta sometime in late 1985 and remembered that one fellow, Greg Jaynes, had said he worked for *Time*. Others on that trip included photographer Slick Lawson and author Roy Blount Jr. Lynn Clark of the Bookworm had rented a Lincoln Continental, and I drove these fellows from Jackson through the Delta to the Peabody Hotel in Memphis. That issue of *Time* included a piece by Jaynes, "In Mississippi: Visiting Around," that began,

Malcolm White, who has been known to leave a trail of hot-tamale wrappers wherever in Mississippi his notions

have nudged him, set out in search of a blues player the other day. White, who books acts in Jackson and has a piece of a nightclub and aspires to open a restaurant, is something of a state celebrant; indeed, so sedulous is his enthusiasm for Mississippi that one need only ride along a few short miles listening to him before the bitterweed growing wild on the shoulders of the road begins to look like daisies, "I get homesick when I have to cross a border," White says, and he means it.

Though *Diddy Wah Diddy* certainly never rivaled *Time*, we published it every month for six years, telling stories and making sure people knew where live music was being played, cool writing was in print, and good food was being served. ■

Charlie Jacobs, Duff Dorrough, Fish
Michie, Bob Barbee, and David "Groovy"
Parker, old Tangents promo picture

THE TANGENTS

Two prominent and overarching cultural assets emanated from the Mississippi Delta when I finally came in contact with the region in the early 1980s: music and food. Locals drove for miles and miles (often while imbibing) across fields and flat serpentine byways to reach one, the other, or in most cases both. So was the most valuable commodity to emerge from the flatland the tamale or the Tangents?

When Charlie "Love" Jacobs died in April 1997, Jill Conner Browne wrote in the *Mississippi Business Journal*, "If you are in your forties and didn't spend the 1980's under a rock, you know and love Charlie Jacobs. Charlie was with The Tangents. Malcolm White, who has heard a couple of bands in his life, says that The Tangents are and always will be his Very Favorite Band. Not just his favorite local band—his favorite band of ALL." Charlie would have been tickled at the idea that his death would get ink in a business publication.

Most Jacksonians think the Delta is mysterious and otherworldly—because it is. I am generally weary of nonnatives who attempt to explain the culture and eccentricity of what some say is the last authentic, southern place on earth. Much has been made of the how the tamale came to the Mississippi Delta, but I find the Tangents' origin story and music just as compelling— pure cultural amalgamation and combustion, white boys playing black dance music and covering everything from Ellington to Elvis.

Steve Morrison, of Cleveland's Morrison Brothers Music, stopped by Skid Marks, one of a handful of pop-up music venues I created and booked during the 1980s, one afternoon while I was prepping for a long night of Oral Sox (or maybe it was Tim Lee, Bobby Sutliff, and the Windbreakers). Steve said I should come out to his car to listen to a tape of a band he was playing with from the Delta. Out of the speakers came the voices and instruments of Duff Dorrough and Charlie Jacobs, the remarkable keyboard stylings of Fish Michie, Steve on bass and Bob Barbee holding down the rhythm section. I heard those white Delta boys playing mostly African American tunes with a peculiar

jazz/R&B orchestration that lent itself to drinking and dancing. I booked them right then and there, sitting in Steve's car. Over the next twenty years, I booked these devilish, disheveled flat-landers more than any other band. I even briefly attempted to serve as their manager, but after I offered some suggestions and put together a few tours, Charlie announced, "The Tangents are simply unmanageable," and we just left it at that.

Late, late one night after a Tangents gig at Hal & Mal's, Charlie ran up to me without warning and jumped on my back. We wrestled and rolled across the floor from one end of the dining room to the other. I finally freed my neck from his hands, and he broke out laughing and announced, "I knew I shouldn't have taken the second Placidyl." I laughed, too. The stunned staff went back to work, and the security guard just shook his head.

The last time I saw Charlie was after he had moved to New Orleans. I was crossing Bourbon Street in the early afternoon and heard a very familiar saxophone playing at the Old French House. I stuck my head in the side door, and there he was in the shadows of the dingy stage, blowing his heart out. He was not the center of attention; in fact, he was just a hired sideman. I took a seat and waited, and at the break, Charlie came over and hugged me. After a brief chat, he excused himself to run across the street to get a beer, telling me, "I can't afford to drink in this tourist trap." He returned a few minutes later with a sixteen-ounce tall boy in a brown bag, and we proceeded to catch up on all things

Mississippi. When the band went back on, he asked the leader if he could do a song for some friends in the audience. The guy grudgingly agreed, and Charlie said, "I want to dedicate this song to an old friend of mine in the audience. He's the only club owner I've ever started a fight with in his own place, and he still hired me back." Heart failure took him not long after that. He is buried on an Indian mound near Lake Beulah.

When I was booking Wellsfest, I asked Duff Dorrough if the Tangents would consider playing. He said I would have to talk Charlie about it. Duff had gotten sober, but Charlie had not. When I asked him about playing the drug- and alcohol-free event, he chuckled, "Hell yeah, man! Free drugs and alcohol? I'm all over that!"

We lost Duff Dorrough in 2012, and the service was held at the Ruleville United Methodist Church. He was interred at the Marlow Cemetery, just a mile down the road from his home and art studio. And though he and Fish had played some Tangent gigs and tried to carry on the magic of those freewheeling Delta years, for me the Tangents' demise began when Charlie moved to New Orleans to chase his own dreams. When we buried Duff, we buried the Tangents, too. Duff and Fish introduced me to Early Wright, Wade Walton, and hundreds of other Delta characters I would otherwise never have had the privilege of knowing. As Jim Dees has said many times, "The Tangents were Mississippi's house band." They certainly were mine. ■

FATHER & SON

This essay was originally going to be called "Brothers Benevolent" and was going to be about our business philosophy: we would open our doors to any and all reputable nonprofits and good community causes. But as I wrote, I began to notice the parallels between Hal's and my lives and that of our father. Maybe it was our Baptist tithing-based upbringing or a true desire to integrate into the community where we chose to do business, but we quickly learned that the more we gave, the more we received. We said yes to many requests, and good fortune came our way. I think it is safe to say that at one time, Hal & Mal's was the largest for-profit business in town that offered complimentary space for almost any nonprofit to use. We were proud of that, and I am proud to say that many others have followed us and adopted this philosophy. Today, most of Jackson's nonprofits can access restaurants, halls, and venues at no charge.

Our approach generated some controversy in 1993 when we agreed to host the first benefit for HeARTS against AIDS. In our conservative southern community, some people were uncomfortable (or worse) about the connection between AIDS and homosexuality, but we felt it was important to join the fight for awareness, and we have never looked back. More recently, we have partnered with the Central Mississippi Blues Society to host a weekly Blue Monday jam session, showcasing this music's important cultural contributions.

Hal and I established several scholarships honoring our father and mother at both Northeast Mississippi Community College and Hinds Community College. When Hal passed, we not only added his name to these efforts but also created other charitable and educational endeavors in his memory. The Hal White Jr. Scholarship is now awarded to freshman or sophomore pursuing a degree in Culinary Arts and Hospitality in the Tourism

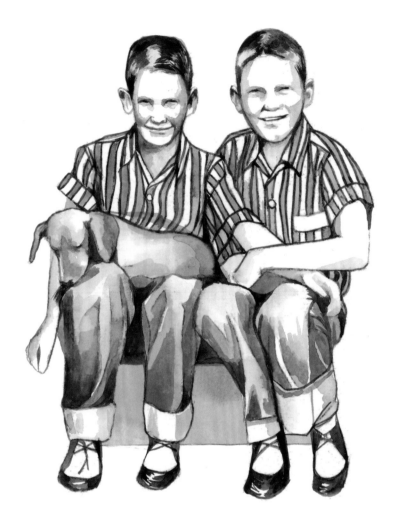

Hal and Mal with
unidentified hotdog

Management Program at the Jackson Academic and Technical
Center campus of Hinds Community College. The scholarship
includes an internship at Hal & Mal's, providing hands-on expe-
rience in the day-to-day operations of a food and beverage busi-
ness. We hope to allow others the opportunity to follow their
dreams, just like Hal did. Dad would be proud. ■

THE ZEN OF WARREN ZEVON

Send lawyers, guns, and money, the shit has hit the fan.

—Warren Zevon, 1978

We were blessed to have presented Warren Zevon in concert at Hal & Mal's a couple of times. He had a real cult following that would always come out of the woodwork when he came to town. Warren played solo in those days, a format that was perfect for Hal & Mal's and that we used for John Prine, Dave Mason, Steve Earle, Richard Thompson, Roger McGuinn, Kevn Kinney, J. J. Cale, Mac McAnally, J. Fred Knobloch, Steve Forbert, and a few others—one artist on stage in front of one thousand attentive enthusiasts who appreciated the music and the craft.

But what I remember most about Zevon was his kind, thoughtful way. He was not demanding, not an ego-tripper, not judgmental or condescending. And when it came to catering, all he ever wanted was a sandwich—specifically, a hamburger. Arden Barnett (Ardenland) handled most of the booking details during this period, and I remember asking, "Arden, what about the catering?" "He said all he wanted was a hamburger. That's all."

Born in Chicago, Warren grew up in Fresno, California, the son of a Mormon woman and her husband, a Jewish immigrant from Russia whose original surname was Zivotovsky and who was mixed up with Los Angeles mobster Mickey Cohen. Young Warren was an occasional visitor to the home of Igor Stravinsky and briefly studied modern classical music with the composer. Zevon's parents divorced when he was sixteen, and he soon quit high school and moved to New York City to become a folk singer. His best-known songs include "Werewolves of London," "Lawyers, Guns, and Money," and "Roland, the Headless Thompson Gunner," all of which appear on his third album, *Excitable Boy* (1978). He also wrote "Poor Poor Pitiful Me," which was a huge hit for Linda Ronstadt in 1978, and numerous other songs.

Zevon was one of David Letterman's favorite musicians and guests and even filled in when bandleader Paul Shaffer was on vacation. In the fall of 2002, Zevon was diagnosed with lung

cancer and given only a few months to live. Rather than spend his remaining time undergoing treatments that might prolong his life, Zevon devoted himself to making one last album, with help from such friends as Bruce Springsteen, members of the Eagles, Emmylou Harris, Jackson Browne, and Tom Petty. On October 30, Letterman turned an entire hour of *The Late Show* over to his friend for conversation and music. When Letterman asked whether Zevon's illness had given him any insight into life and death, he responded, "Enjoy every sandwich." Letterman later reflected, "Here's a guy looking right down the barrel of the gun. And if a guy wanted to indulge himself in great hyperbole in that circumstance, who wouldn't forgive him? But that was perfect, the simplicity of that. If this guy is not a poet, who is?"

Yes, Warren Zevon played Hal & Mal's and enjoyed every sandwich. ■

Enjoy every cheeseburger.

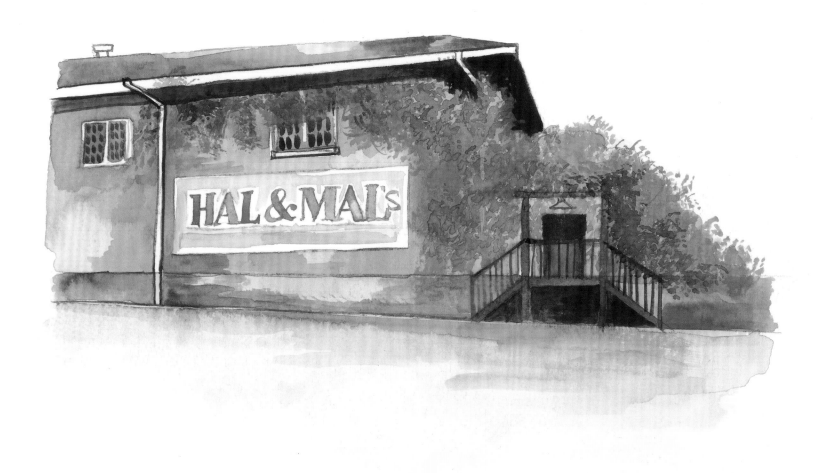

Exterior of building, sign painted by
A1 Signs, and courtyard entrance

TAXES & THE TAX MAN

I don't know if it's true in other states, but in Mississippi, the government agencies that are responsible for collecting revenue (and thus getting money that that very same government can spend on economic development, infrastructure repairs, education, the arts, health, and all sorts of other functions) do everything they can to prevent the hospitality industry (except casinos) from succeeding. I do not understand this paradox. You'd think that these agencies and the people who run them would figure that they would benefit from the additional taxes collected when restaurants etc. prosper. But in health inspections, beer and liquor licensing and enforcement, and numerous other ways, Mississippi discourages growth in this industry. State officials pick and choose what laws to enforce and which establishments and license holders to target, ignoring blatant violators who serve minors, operate outside of legal hours, disregard smoking ordinances, and otherwise do as they please. Everyone in the business in Mississippi knows this. And often, the more successful a business becomes, the more closely it is scrutinized and more harassment it endures. Our leaders claim to be pro-business, pro-entrepreneurial, and pro-innovation but continue to run these operations as they did in the whiskey-still-busting days of the 1920s. The system is political, inept, and antibusiness.

Our family has worked in this arena for forty-plus years and transformed total economic decay into a thriving creative outpost. We have invested millions and managed to make a decent living. But since the day we obtained the lease on this building, we have fought the tax authorities. We have argued for thirty years about whether we are responsible for property taxes on property we do not own. Members of the right-wing fringe and trolls have aired their grievances against us in the *Clarion-Ledger*. We've endured boycotts and hostile demonstrations in our establishment and received death threats over our position on the state flag. We have been under audit for so long that the auditor has his own desk in our office. We will be exchanging Christmas gifts with the auditor and his family this year—nice guy, tough job. When a governor disliked our politics, our multiyear lease was

revoked and we were placed on a year-to-year lease basis. Nevertheless, we are still here, having outlasted half a dozen governors and mayors.

In 1966, the Beatles released their first George Harrison–written song, "Taxman," the opening track on *Revolver*. Its lyrics present the Beatles' protest against the British Labour government's high levels of taxation. This is our song, and we'll try not to sing out of key. ■

THE ARTISTS UPSTAIRS (& DOWN)

Not all relationships, family or otherwise, survive the rigorous test of time. Relationships begin for a variety of reasons—proximity, envisioned mutual benefit, artistic appreciation, a shared vision—but can fray as a consequence of demands for loyalty, the changing landscape, and other stresses.

When we first got the lease on the old GM&O Freight Depot, the only occupant, other than an assortment of homeless drifters and bus stop vagabonds, was a small creative outpost, Bright Image, a lighting and costume shop owned by Bruce Ingebretsen. Although I thought Bruce's business would make a great complement to what I envisioned for the space, my partners disagreed, and he moved on.

Once we moved in and began reclaiming the space for Hal & Mal's, my then-sister-in-law Carole Pigott, a gifted painter, asked if she could use part of the upstairs space as a temporary studio and living space. She came armed with a business proposition: in exchange for low rent, she would do basic renovations to the space. Thus, our partnership was born of reciprocal needs. She subsequently convinced me to extend the same deal to other artists: affordable space in exchange for renovations and improvements. P. Sanders "Sandy" McNeil, Richard Kelso, John Maxwell, and John Hamrick were the first to take advantage of this offer, and over the next thirty years, a variety of artists have come and gone (or stayed), created workspace, succeeded and failed. Sergio Fernandez set up a recording studio downstairs in the 1980s and is still there. Among those who have shared our space are James Treadwell, Bobby Pennebaker (now associate professor of art and chair of the Visual Arts Department at Belhaven University), Laurin Stennis, Heidi Flynn, Lil McKinnon-Hicks, Sean and Christian Johnson, *Planet Weekly*, Hubert Worley, Jack Stevens, Red Tape Productions, Times Fly, Ardenland, the *Diddy Wah Diddy*, A1 Signs, Vivian Neill, Tyler Cleveland, Anna Wolfe, O. C. McDavid, the *Southeron*, and Jack Mallette. This was Jackson's very first creative economy. On Carole's watch, the Midtown Arts District partners conceived and launched Holiday Studio Tours, which

first prospered and then ultimately unraveled, much like Jubilee! JAM and the Jackson Arts Festival.

What happened over the years at Hal & Mal's was not an isolated and transformative individual act but rather a spark, a pilot project that showed what was possible. Many others also labored to explore Jackson's creative possibilities. Pearl River Glass Studio began in 1975 in Midtown as Andy Young pursued his dream of establishing a professional studio providing state-of-the-art stained glass to clients across the country. Other innovative revitalization efforts sprung from the brains of Chip and Debra Billups, Susan Ford, Elizabeth Robinson, Ed Millet and Gretchen Haien, Josh Haley, Andy Hilton, and the many other soldiers in the Midtown arts army.

As a direct result of our shared space collaboration, Richard Kelso painted *Malcolm 1993*, which is now in the permanent collection of the Mississippi Museum of Art. On a couple of occasions, I climbed the stairs to Richard's studio and sat in an old chair that he had found from the movie *A Time to Kill*. And then I fell asleep. The painting depicts me and the chair not in the chaos of the downstairs at 200 South Commerce Street but in the serene, tranquil studio that Richard fondly refers to as his "magic chamber."

In some ways, Hal & Mal's, too, is a magic chamber. We're not just a bar and restaurant; we're a creative outpost in downtown Jackson. ∎

Richard Kelso in the "magic chamber."
Photo by James Patterson.

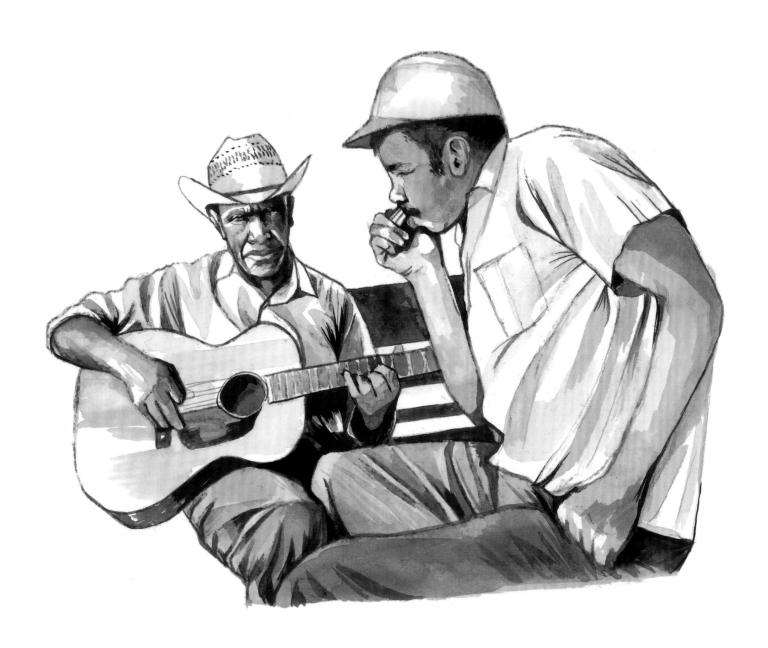

Jack Owens and Bud Spires
with Mal's old EKO guitar

JACK OWENS & BUD SPIRES

When I was in high school and the Beatles, the Rolling Stones, the Hollies, and the Byrds were in style and on the air, I took up playing music, promoting live shows, and booking bands. Booneville had a band, the Phinx, whose front man, Mike Cunningham, lived a stone's throw from our house. My playing was pretty much limited to the handful of three-chord ditties I could pick up by ear on piano and guitar, so I spent most of my time onstage as a roadie, occasionally sitting in for musicians who wanted to dance with their girlfriends. I played a little with a folk group, the Original Five Minus One Plus Mal (think Peter, Paul and Mary, only without Peter, Paul, or Mary), but mostly I just played for my own entertainment. However, once Roger McGuinn of the Byrds introduced my generation to the twelve-string guitar, I knew I had to have one. And for my nineteenth birthday, my dad bought me an EKO twelve-string from the Bennett Brothers Blue Book of Quality Merchandise. Because Mike Cunningham was the only person in town who could tune the thing, I then spent a lot of time around the Cunningham house trying to keep my guitar tuned, learn a thing or two from the master, and keep secret my crush on Mike's beautiful sister, Donna. Later in life, I had the good fortune to tell Roger McGuinn that his influence had led to that great chapter in my life.

Between my high school graduation in 1969 and my arrival in Jackson a decade later, I attended five institutions of higher learning and spent three summers in Washington, DC; a year in Northern California; and two years in the French Quarter. The EKO (rarely tuned) accompanied me throughout this time, mostly tucked under the front bench seat of my 1971 VW van. By the early 1980s, I had transitioned from folk to rock to jazz and finally to the taproot of the blues, living as I was so close to its heartland in the Mississippi Delta. To my great surprise and delight, many legendary blues icons were still around and making music. B. B. King was in his prime and frequently returning to Mississippi, Muddy Waters was still kicking in Chicago, and a plethora of Mississippi-based blues masters remained

even closer to home. I became great friends with Sam Myers, Jesse Robinson, Bobby Rush, and King Edward in Jackson and found many others working north in the Delta and the hills—Son Thomas, Eugene Powell, Sam Chatmon, Booba Barnes, Boogaloo Ames, R. L. Burnside, and Junior Kimbrough. In Bentonia and Flora I discovered Jack Owens and Bud Spires, playing an occasional gig at the historic Blue Front Café, owned and operated by bluesman Jimmy "Duck" Holmes. As often as possible, I tried to hire Jack and Bud to play Hal & Mal's, Jubilee! JAM, and other gigs, and I took folks to see and hear him in Bentonia whenever I could. In late 1985 I took a group of people on a tour of the Delta that included a stop to hear Jack and Bud. One of the people on the tour was *Time*'s Greg Jaynes, and he wrote about the trip—and Jack and Bud—in a piece that appeared in the magazine's June 9, 1986, issue. Soon after I met Jack, Steve Forbert and I were traveling together and showed up at Jack's house to play, only to learn that someone had broken into his home and stolen his National Steel. Steve had his guitar and harp, so the two of them jammed on Steve's box. When I got home, I decided to give the EKO twelve-string to Jack. A week later, I returned with the instrument and presented it to him. He looked it over, smiled so that his gold front teeth showed, and removed six of the strings. He played that guitar until his death in 1997. Lead Belly and Jimmy Reed played the hell out of the twelve-string blues, but they just weren't for Jack. And when he died, someone again broke into his place and stole the EKO. Perhaps today it's hanging on the wall of a Hard Rock Cafe somewhere, totally out of tune. ■

ST. PADDY'S PARADE

Late in 1982, I had recently quit my full-time restaurant job. After eight years of working twelve-hour days, including every weekend and often running multiple establishments, I was tired. I needed some time to myself, and I needed new inspiration. I was fishing around for some consulting work, some sponsors, and I wanted to establish my own creative business. I tried a bunch of stuff. Some of it worked; some of it didn't. Sometimes I got paid in free meals, sometimes with used equipment, sometimes in cash; sometimes I got stiffed. I would work the phone all morning, booking bands and events; head to the YMCA for noon basketball; and then spend the rest of the day in meetings and on the phone until one of my bands hit the stage somewhere in the city. I was still booking George Street and the Pyramid and was working with Jubilee! JAM, but I was itching to produce something of my own. One day I was sitting at the downstairs bar at George Street talking to my longtime friend and co-worker Cotton Baronich, mixologist and storyteller extraordinaire. Raad Cawthon walked in and joined us at the bar.

Raad wrote three columns a week for the *Clarion-Ledger* and was always looking for a lead, so he asked what I was up to and what was going on. Over a beer, I told him that I had been toying with the idea of producing a St. Patrick's Day Parade to complement the highly successful St. Paddy's–themed activities we had started a couple of years earlier at George Street. He listened and asked a few questions, but nothing formal. Two days later, Raad's column announced the upcoming parade. I was screwed. I had about two months to put together something resembling what Cawthon had shared with the world, or at least my corner of it.

I started calling all my friends. My first thought was a pub crawl beginning and ending at George Street. Downtown Jackson had only one other bar within crawling distance, CS's, so I talked to Joey Mitchell at George Street and Pat Bolen at CS's. They both were interested. Next I needed sponsors. My go-to sponsors in those days were my cousin, Dink Drennan, at Capital City Beverages and Marshall Magee at WJDX Radio. They said yes. Vivian called Jill Conner Browne and told her I was

Tiny Tim and his ukelele

planning a parade, and then the Sweet Potato Queens were on board. The Bluz Boys were recruited, Charlie Hyneman and Ann Hendrick at Walker's Drive-In joined. Once word started getting out, people started calling me, and soon I had Kathryn and Jim Dollarhide, Carole Pigott, Sergio Fernandez, Raphael Semmes, Jay Stricker, V. A. Patterson, Sam Myers, and a few dozen others. Now I needed a grand marshal. Brian O'Shay called and suggested Thalia Mara's husband, Arthur Mahoney, a cowhand who had left a Texas ranch for a career in ballet. He was Irish, an ex-boxer, and a dancer—perfect. Van Anglin was recruited to bring his convertible, a sash was ordered, and a few bagpipers were enlisted. It was starting to look like a parade; all I needed now was a permit. So I went downtown to the Jackson Police Department and got a permit for Thursday, March 17, 1983, at 4:30. The parade would start at CS's on West Street and then

go south to Capitol Street, east to President Street, and back up north to George Street. Easy. I got David Adcock to create artwork for a poster, and the pieces began to fall into place. The frat boys at Millsaps just across the street from CS's got wind of the goings-on and in the best *Animal House* tradition threw together something for the occasion. I needed a trailer for the Bluz Boys to play on, so my great friend Sambo Mockbee wrote us a check. Raad, Bill Nichols, and Karena Cawthon put together a *Clarion-Ledger*-sponsored entry, "News You Can Use": Raad and Bill put on green foam fish heads, wrapped themselves in newspaper, and rode along in the back of Raad's pickup with Karena at the wheel. They were tossing rolled-up newspapers to the onlookers and drinking from a keg of green beer (courtesy of the *Clarion-Ledger*). Handwritten signs on the doors of the pickup helpfully explained, "P.S. We are fish." That was the last

Early parade led by the
O'Tux Society

time the paper sponsored a float. Thirty-five years later, Jill and the Queens are still using that trailer. The Buckethead Judges, created by Sambo and now in the able hands of Peyton Prospere and Ward Emling, preside over the affair and bestow awards.

All went well until Mal's St. Paddy's Parade (as it was officially known) hit the streets during rush hour traffic. Downtown in 1983 was very different than it is now: thousands of people drove in at 7:30 in the morning and out at 5:15 in the evening, and, man, were they pissed when they found the streets blocked off, preventing them from heading home. By the time we arrived at Capitol Street, cars were backed up on every major downtown thoroughfare. People were standing next to their running cars, honking their horns and waving their arms in the air. "Adoration," I thought. Nope. They were angry about the intoxicated hooligans who had taken over the streets—with a police escort, no less.

The following day's headlines did not trumpet the amazing, festive outing we had gifted the city; instead, they asked why on earth the City of Jackson had allowed these renegades to disrupt traffic and cause mayhem on an otherwise ordinary Thursday afternoon. Though the St. Paddy's Day tradition had begun and we had made our point that we owned downtown Jackson, from then on, the parade would take place on the third Saturday in March, not on a weekday.

One year, we invited Tiny Tim to serve as grand marshal. He arrived as advertised and spent two days entertaining us and enjoying Jackson. After the parade concluded, he joined the Bluz Boys Band onstage for a rousing version of his hit, "Tiptoe through the Tulips," before ending the set on his back, rocking out on his ukulele as he and the band played "Stairway to Heaven."

An awful lot has transpired since then. Our little band of misfits has cleaned up our act (at least to some extent) and partnered with the Blair E. Batson Hospital for Children. Jill has gone her own way, producing an exceptionally successful event in Fondren that not only contributes greatly to the cultural and creative economy there but also benefits Batson.

In 2015, Mal's St. Paddy's Parade became Hal's St. Paddy's Parade in honor of my brother, who loved the parade and downtown and who joined me, Raad, David Patterson, Tom Massey, and Chris Shoemake in establishing the ancient and benevolent O'Tux Society. ∎

THE TWENTY-FIRST CENTURY

I recently ran into an old friend, Liz Carroll, at the GRAMMY Museum Mississippi in Cleveland at the unveiling ceremony for a Mississippi Blues Trail Marker. We talked about Hal & Mal's, Mississippi, and our arts and culture scene. I have had the privilege of serving on the Mississippi Blues Commission and on the advisory panel for the Mississippi Country Music Trail, and I consider them and the Mississippi Freedom Trail the greatest cultural success stories of my lifetime. That said, the openings of the B. B. King Museum, GRAMMY Museum, and Mississippi History and Mississippi Civil Rights Museums certainly rank high on that list.

Liz remains loyal to Hal & Mal's. She spoke highly of P. J. Lee and our longtime staff, led by Flo and Lela Courtney, Darryl Dampier, and "Killer" Carl Jackson, but Liz also said that she sorely misses Hal's seasoned hand in the kitchen as well as his "witty repartee and cynical asides." I almost burst out laughing in the middle of the Stevie Ray Vaughan exhibit, where I had just watched Jimmie Vaughan describe his relationship with his little brother. This brothers business is complicated.

Most of the stories I've told here have been about life in the twentieth century. By 2000, I was slowing down, spending more and more time away from Hal & Mal's, and trying to figure out what I wanted to do next. Hal was running the show, both loving it and bitching every day about how I had abandoned him. We had our struggles as business partners, and I felt like he was ready to have his own time at the helm. I had moved to Grayton Beach, Florida, and back to Jackson; gotten divorced; and begun to lose my interest in the entertainment business. Where it had once been about the music, it had become about the artist's contract and rider. I was burned-out, bored, and feeling sorry for myself rather than grateful for all that I had. It was a weird time. Bruce Browning and I began paddling, fly-fishing, and traveling in search of Hemingway, Thoreau, and Yeats. We explored the Upper Peninsula of Michigan, the Canadian Boundary Waters,

Mal-style (thin) and Hal-style
(thick) onion rings

Brandi and Rivers

the rivers of Arkansas, and the Gulf of Mexico and its tributaries. We "Paddled the Pearl" for Batson's Children's Hospital and made our way up and down the streams and rivers of the Pascagoula system. We traveled to Ireland and Scotland with Carol Puckett and Estus Kea. I visited Italy and Morocco with my great friend Elaine Trigiani. Peyton Prospere and I rented an apartment on Governor Nichols Street in the French Quarter, and then Bruce and I rented a small cottage in Back Bay Biloxi and tried to imitate Walter Anderson and George Ohr, two great Coast artists who paddled the rivers; lived a free, bohemian lifestyle; and were creative and fun-loving. In 2002, I bought a great old Creole house in Bay St. Louis. I bought boats and revisited the coastal waters of my youth. We fished and cooked and drank, and I spent more and more time in the bay and less and less in Jackson. On a whim, I bought a house on Manship Street in Belhaven in 2004 and moved out of the glorious apartment over Hal & Mal's that had been my home for thirteen years. (My daughter, Zita Mallory; her husband, Jonathan Webb; and their daughter, Wren, live there today.) By the time Katrina landed at my door in August 2005, I had made a dramatic lifestyle change and was ready to start over. I had wallowed in self-pity and consumed enough wine since the beginning of the new century to float Noah's Ark, and I had had enough. With the support of my family and friends, I gave up the bottle, rose up, and began to walk upright. Bill Nichols; Carol Puckett; Peyton Prospere; Tom Massey; my brothers, Hal and Brad; and my daughter, Zita Mallory, stretched out their hands and helped me find a power greater than myself and a new life. On October 1, 2005, I accepted the position of executive director of the Mississippi Arts Commission and turned over a very new leaf. I was fifty-three years old.

As I moved into public service work, Hal continued to hold down the fort at Hal & Mal's. I stopped by often and assisted when and where I could with finances and big ideas, but mostly I was working for the state. And then, in late March 2013, just a week after his sixty-fourth birthday, completely out of the blue, Hal suffered an aneurysm. He died a couple of days later. I had just assumed a new job as the state tourism director with the Mississippi Development Authority.

Hal's passing stunned me and the rest of the family. I had made a commitment to my new post and honestly didn't have the energy or passion to return to the hospitality game. But our children just kind of naturally stepped in. When she wasn't at her day job, Hal's daughter, Brandi, started spending all of her time on the floor and in the office, organizing. P. J. Lee took off his lawyering suit and put on an apron. Zita Mallory gave up her Lemuria Bookstore gig; her then-boyfriend, Jonathan, left Sal & Mookie's; and they, too, joined in. Hal's son, Taylor, returned from California to pitch in (whenever Phish wasn't touring, that is). And despite being brokenhearted at Hal's death, Mama Zita continued to show up two days a week to do the reports, greet the customers, and ultimately to keep everyone's spirits up during a dark and transformative time. Our managers and staff also put their shoulders to the wheel to keep Hal & Mal's doors open. At first, the attitude was "Let's do this for Hal"; then it became "Hey, this is our family business." It took a while, but we found a new order. Zita Mallory and Webb got married, moved into the apartment

upstairs where she grew up, had baby Wren, and eventually decided to step away from the family business. Taylor moved to Memphis to go back to school and be with his fiancée, Sam Davis. Now, Brandi and P.J. do most of the day-to-day work, following Hal's recipe cards to the letter and shaping the space and the feel to fit their generation and the twenty-first century. Life goes on, and Hal & Mal's moves artfully into the next chapter.

The new blood has brought many improvements. The Blue Monday partnership with the Central Mississippi Blues Society is a very positive tourism and cultural component. The building has been remodeled, repaired, and cleaned, and the new deck off the Big Room is amazing. We've expanded into catering, cooking and serving at other venues, festivals, and private homes, a new and aspect of the business that never much interested Hal: he would say, "Hell, if they want to eat our food, they can come to the restaurant." Hal minced garlic, not his words.

No one knows what the future will hold, for Hal & Mal's or for anything else. But as long as we have our people—family members, bartenders, cooks, waiters, dishwashers, managers, busmen, musicians, and patrons—we will have our community. ■

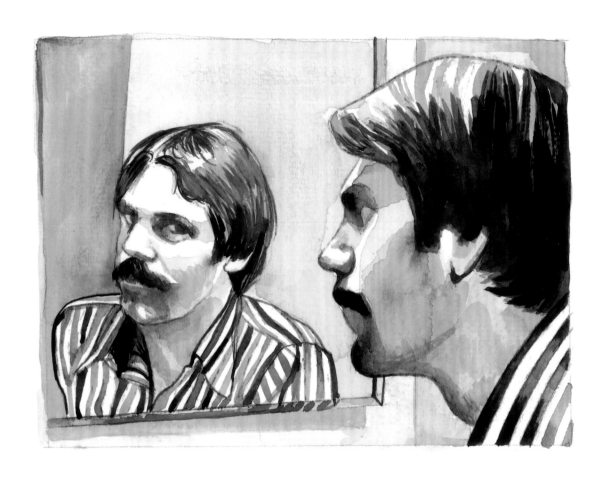

Hal posing for Mal's photography class
in the mirror of their shared bathroom
in Booneville, ca. 1973

AND, IN THE END . . .

Harold Taylor White Jr. was born on March 13, 1949, and died on March 28, 2013, just a week after bragging at Bill's Greek Tavern that he had "outlived the old man"—our dad, who suffered a massive heart attack and died at age sixty-three. Hal was full of spit and vinegar right up to the end.

Though I knew him all my life, I now realize that I knew only a little. I cannot speak of the love between Hal and Ann, of his kinship with his golfing buddies, of his bond with his kids, or of the intricacies of his faith. I do not know the complexities of his soups and stews, and I cannot fathom his undying loyalty to Mississippi State, an institution that kindly asked him to abandon his studies and leave campus in the middle of his college career. But he was my brother, my business partner, and my closest friend. I loved him. I think that we rarely realize the importance of siblings until we lose them. Our brothers and sisters are the verbs that give action to our nouns, our lifelong

mates. Hal and I completed each other, quietly supported one other, and looked to each other to fill the empty spaces. Survival can be lonely. I'm not sure that I anticipated or could even imagine what it would be like without him. I have no idea of how to proceed. I am humbled by his absence and diminished by his passing, but I am grateful for the years he shared with me and for his love and tolerance.

We grew up as Hal&Mal—no spaces, inseparable, "the boys." Our mother died when we were small, and we were raised by our community, our family, and primarily our grandparents until our stepmother came along. And then Brad's arrival expanded the White brothers from a duo to a trio.

By the time we got to high school, Hal and I had started to move in (at least slightly) different directions. In the Boy Scouts, Hal was an Order of the Arrow; I never made second-class. He was a quarterback; I was a blocking fullback. He was elected Most Handsome, while I was Most Carefree. He paged for US representative Jamie Whitten, while I spent summers working

A version of this essay also appeared in *VIP Jackson*, July 2013.

for US senator John Stennis. By the late 1960s, he tended toward fast cars, Raquel Welch, and the Beach Boys, while I tilted toward Frank Zappa, Janis Joplin, and our old Willis Jeep. We grew up Southern Baptist; Hal converted to Catholicism. He loved Mississippi State (where he and I briefly shared a dorm room, though I rarely slept there); Dad and I graduated from Southern Miss, and Brad got his degree from Ole Miss. Hal joined the National Guard, while I was graced by a triple digit lottery number. He was off to basic training, and I was just off. But our lives always remained interwoven. We shared clothes, apartments, houses, cars, and friends, dropped in and out of colleges, dated a few of the same women, and never lived more than a few miles apart except for when I was in California in 1973–74. He once got me a job working on a construction crew; I hired him to run the dining room at the Bourbon Orleans Hotel, and we worked and lived together in New Orleans for several years. For a while in Hattiesburg, we were archcompetitors—he ran the Holiday Inn, while I helmed the Ramada. Sometime in the mid-1970s, we decided we would someday open our own restaurant, use family recipes, book live music, and cover the walls with Mississippi art and culture. And a decade later, we did.

Behind his gruff facade, Hal was forever sanguine, optimistic, and cheerful. He was a paradox: a simple guy, an everyman, who quietly touched many, helped hundreds, and held together a complex network of family, friends, and community, overseeing his kingdom from his favorite bar stool at the south end of our family business. From this perch, he held court, conducted interviews, entertained the media, counseled his troops, gave advice (wanted or unwanted), ate his lunch, offered sports prognostications, drank his coffee, and received his public. More likely than not, if you wanted to talk to Hal, you came to Hal. He did not work the crowd like our masterful father, who glad-handed his way across a dining room like a candidate on the campaign trail while we sat and waited to start eating. (I inherited that gene, as Zita Mallory will tell you.)

He certainly had his opinions and was not shy about sharing them. He hated certain corporate food giants and refused to buy their products. He loved a good protest and was happy to tell you how he felt about some politicians and popular trends. He declared unequivocally that pizza was a fad and that Facebook would fail. In 2000, he (and I) supported Bill Bradley for president.

Hal White was my rudder. He was the rock, I was the roll. We were a team with no coach or captain. We did not fight or argue, though we certainly did disagree from time to time. Our modus operandi was quiet compromise. Our brotherhood was first, our business life followed. He did not like all of my ideas; I did not like all his decisions. But we always found common ground and remained focused on our shared goal. We were after all, Hal&Mal. He often reminded me that his name preceded mine on the sign out front.

Hal, like most of us baby boomers, dearly loved the masterful wordsmithing of Lennon and McCartney, so I think it fitting to close with some of their most powerful words—words that unquestionably apply to Hal: "And in the end, the love you take is equal to the love you make." ∎

INDEX